TRAVEL WRITING

TRAVEL WRITING

JANET MACDONALD

ROBERT HALE · LONDON

ISBN 0 7090 6616 3

Robert Hale Limited
Clerkenwell House
Clerkenwell Green
London EC1R 0HT

2 4 6 8 10 9 7 5 3 1

Typeset by
Derek Doyle & Associates, Liverpool
Printed in Great Britain by
St Edmundsbury Press Limited, Bury St Edmunds
and bound by
Woolnough Bookbinding Ltd

Contents

Acknowledgements

My grateful thanks to Tim Harper, Keith Kellet, Brian Kilgore, Kit Snedacker and all the other travel writer members of the Journalists' Forum on CompuServe who offered information and opinions, and as always to my husband Ken (photographer, chauffeur, bag-carrier, linguist, editor and proofreader – not to mention coffee-maker par excellence!).

Introduction – What Is Travel Writing?

For many people, travel writing is typified by the long articles in Sunday papers or the books of Colin Thubron, Dervla Murphy or Bill Bryson. The newspaper articles are usually what are known as destination pieces, describing a holiday location or occasionally a journey taken as a holiday: a train ride on the Trans-Siberian Express or a week on a Rhine cruise. The books tend to be about voyages of exploration through a whole country or even several countries, with a specific aim in mind: to examine the state of the nation after some great political event (such as Colin Thubron's *In Siberia*) or to follow the trail of historical personalities (such as Tim Severin's *The Brendan Voyage*).

But this is only the tip of the iceberg. For every journey book there are many other books of travel: guidebooks, books of health tips for travellers, books for parents travelling with young children, books for business travellers, books listing courses you can attend while abroad, and books on the practicalities of setting up home in a foreign country. For every destination piece in the Sunday papers, there are many similar articles in daily and regional papers, all sorts of general magazines and specialized travel magazines. Other travel articles in these publications cover the topics mentioned above, plus all the other aspects of travel

7

and holidays: reports on safety issues in certain countries, news of the latest lightweight luggage, details of bargain holidays, and reviews of the latest guidebooks.

That is just the consumer holiday market; in book and magazine form there is also business travel, living and working in another country or buying and renovating a home abroad. And in all this variety, as well as the printed versions there is now an increasing electronic marketplace for the would-be travel writer.

Travel writing could be summed up as being about going away and being away, whether abroad or in your own country. Writing about holidays or days out in this country is still travel writing, even if it is aimed at your fellow inhabitants. It can equally be aimed at readers abroad, thus enlarging the potential markets for your writing.

Who Reads Travel Writing and Why?

As will be seen from the brief overview above, travel writing is such a wide field that it attracts an equally wide readership, each with their own area of interest. However, people who read travel writing do tend to fall into two main types: armchair travellers and practical travellers.

Armchair travellers rarely make the sort of journey they like to read about; for them reading about faraway places and long journeys is part of a favourite dream. Some may never realize that dream, others may not be able to do so until they reach retirement, but all want to read writing that brings the experience of travelling to life. The term 'faraway', of course, is subjective and the dream is just as likely to be about hillwalking in North Wales as about a camel trip along the Silk Road. For many people, reading about exotic travel is a way of escaping from dreary winter weather or dreary lives doing boring jobs.

Practical travellers are those who do intend to go to the places described and are seeking information on where and when to go, how to get there, where to stay and what to do when they arrive. More and more of them want information slanted towards their personal inclinations such as vegetarian food, or essential requirements such as wheelchair access. There are many readers in minority markets who have been largely ignored by mainstream publishers, and this offers excellent opportunities for writers who can spot and fill the need for this niche information.

Why Should You Write About Travel?

More to the point, is your ambition actually to write about travel, or just to travel, with the hope that the writing will serve to subsidize your journeys? There have been a number of mail-order courses advertised recently which promise novice writers that they can not only get free holidays but make money by writing about them. You can indeed do this, but only if you work to develop your writing skills and take the trouble to study the markets for such writing. How this can help to fund your own travels is explained in detail in Chapter 9.

It has to be admitted that travel writing is not a way to make a fortune, unless you have the talent and luck of a Bill Bryson, but if you are able to obtain regular commissions from mainstream publications you can do quite well. Of all the people who write travel articles and books only a small proportion write solely about travel; most write other things as well and for them travel writing is another string to their bow. If you are a writer, you can't *not* write about your experiences; you automatically observe what goes on around you in terms of what you can write about it and what is the likeliest market for that writing.

Once you accept that travel writing encompasses many different sub-categories, you will find that articles which you have had published at home turn into travel articles when sold abroad. Sometimes they can be resold as they stand, more often they need a little rewriting. For instance you might sell an anniversary piece about a chain of fish and chip shops to the local newspaper or county magazine of the town where the first shop opened. It would concentrate on the founder of the chain and how he came to be in that particular town, and if appropriate would also mention that he went to a local school and married a local girl, and that his children still live in the district. It would also include some of the history of fish and chips itself as what has almost become the national dish.

To turn this into a travel piece for magazines abroad, you would write a new introductory paragraph which might go something like this:

> The British don't live on a diet of roast beef and Yorkshire pudding. For most families it's more likely to be fish and chips, that delightful dish of fried potatoes and crisply battered white fish. Aficionados argue about whether oil or lard is the best frying medium; Charlie Higgins, owner of a franchise chain of fish and chip shops in the UK, insists, 'It must be lard.'

Then you would add a new closing paragraph which goes something like this:

> As well as the eighty-seven shops in the Charlie Higgins franchise chain, every town in the UK has at least one independently run fish and chip shop, so you won't have any difficulty in sampling the delights of this national dish next time you visit Britain.

What Sort of Travel Writer Do You Want to Be?

This question can be superficially and quickly answered by saying that you will want to write what you like to read. This is true of all writing and if you want to be published you will also need to be aware of the old adage, 'You can't write for it if you don't read it.'

Where travel writing is concerned, what you can realistically write about will often be dictated by your physical situation. If you are over 65, and arthritic and can't swim, you are not going to be able to sample sea kayaking or whitewater rafting trips so that you can write convincing pieces about them, although you could produce round-up pieces on what trips are available. Serious travel writing is not for the fragile; you do actually have to be pretty healthy to sustain the rigours of even a short press trip. Typically these can involve several days of visiting every museum and tourist attraction in town, having to eat two full meals each day and move to a different hotel each night. This might sound enjoyable but you will rarely have a moment to yourself and it can even be difficult to find time to write up your impressions of each day before you fall exhausted into what will not necessarily be a comfortable bed.

Then there is the difference between the sort of writing you would like to do and the sort you can get published. The necessity of earning a living often means that while you might secretly yearn to write about epic journeys, you may have to settle for a sequence of shorter trips which your readers can emulate during their annual holiday. This is not to denigrate these shorter pieces; if you have the urge to keep on the move, a series of short trips is almost as good as one long journey, and they also have a higher earning potential.

11

Can You Sell Your Travel Writing?

Certainly you can, provided you follow the simple rule of studying the markets and writing the sort of pieces they want to buy. Few magazines or newspapers these days have travel writers on their staff, so most editors use freelances and they are more concerned about your writing ability than whether you belong to a professional travel writers' organization. Some of the top glossy magazines do like to use writers whose names are already well known to their readers from other fields. For instance a famous chef might be asked to do a series on exotic hotels with good restaurants, or a Grand Prix racing driver might do some articles on driving holidays. But less prestigious publications cannot afford the fees these exalted people ask and are happy to use newcomers.

As with all new ventures, the trick is getting your foot in the door. If you have a body of work published in other genres, you will be well on your way, as this shows you can write; otherwise you may have to downgrade your expectations a little until you do have some published work to show, starting with small papers and magazines instead of the big names. Either way, it is perfectly possible.

1 Articles and Short Pieces
of Travel Writing

There are so many potential markets for travel writing in the UK alone that no matter what your preferred aspect of travel, you should not find it too difficult to sell your work. Here is a brief run-down of the obvious and less obvious possibilities.

Newspapers

For the new travel writer, the situation with British newspapers is, quite frankly, not good. Although there are dozens of papers, from the big national dailies and Sundays to weekly local papers, their content is hardly ever commissioned from unknown freelances. The big papers have editorial teams which block out what they want many months in advance of publication date and commission either staff members or favoured freelances to write it. They receive dozens of impressive CVs from other freelances with suggestions and dozens of manuscripts from hopefuls, but they hardly ever use any of these; they prefer to work with writers they know and trust to do a good job.

The big regional UK newspapers might have a dedicated

travel editor; smaller papers will have someone who carries the title but also edits other feature areas. Travel items are either written by various staff reporters employed by the paper or obtained from syndication agencies for a few pounds (one agency actually provides travel features free to its subscriber newspapers). The travel editor of one big group of local newspapers, when consulted on this topic, said that he used to publish items supplied by freelances who were prepared to submit them for no fee but that he no longer did so because he had found that some of them abused the situation by pretending to be employees in order to obtain free press trips.

One possibility for acceptance in regional papers is the 'Travel News' section. These may consist of no more than a round-up of what is available in the way of cheap flights and bargain holidays, compiled by a staff member from information sent to the papers by public relations agencies, but some include brief news stories about local attractions. If you find that one of your local attractions, or a popular attraction which falls within your chosen speciality, is closing permanently or temporarily (perhaps as the result of some accident), it is worth ringing round some likely papers and asking if they would like a story about it. Be aware that they might prefer to send a reporter to check it out, in which case they should pay you a 'finder's fee'.

Newspapers abroad are a better option for selling your travel writing. America in particular has hundreds of small local and regional newspapers (although many of them use syndication services). To find out which might be possibles, you need to consult either *Benn's Press Directory* for the relevant country or one of the many market guides such as *Writers' Market* or *Travel Marketing Sources. Benn's Press Directory* should be available in your local reference library, but you will have to buy the others.

Magazines

Starting at the top, there are the prestigious glossy monthly travel magazines like *Condé Nast Traveller* and *Food & Travel*. As with the national newspapers, the chances for novice writers to get into these magazines are virtually non-existent. The same applies to other glossy monthly magazines such as *Gourmet* which, although not dedicated to travel, do regularly include travel features. All these magazines pay high rates and the competition among professional travel writers to get into them is correspondingly high. They are also demanding to write for; the editors have very definite ideas of what they want to see and it is not unknown for writers to have to do two or three rewrites before the editor is satisfied.

Then there are numerous other dedicated travel magazines which cover specific areas or topics. Some, such as *France* cover certain countries; others cover specific activities, such as *Walking Abroad*. Most of these are happy to take articles from freelances. They may not pay terribly well and some of them will not give you a firm commission, even after they have published several pieces of your work. They will give a definite 'no' if they don't like the idea, or have recently featured something like it, but never anything firmer than 'We would be pleased to consider it'. Since some of these magazines only publish four or six issues a year and tend to have a large stock of articles, it can be a long time before your work appears in print even after it has been accepted – as much as a year in some cases.

Then there are numerous magazines which, although dedicated to a specific (non-travel) purpose will accept articles which cover their topic in another country. For instance, there are magazines for car owners and drivers, ranging from *Autocar* through *Mercedes-Benz Buyer* or *The Volvo Magazine* to *AA Magazine* and *Motoring & Leisure* (for

members of the Civil Service Motoring Association). All of these are possible markets for pieces on driving abroad. Others, such as *Amateur Golf* or *Riding*, publish seasonal features on holidays for enthusiasts of their sport. Where the car magazines prefer pieces on destinations or routes, with occasional round-up pieces such as 'Things you need to know when driving on European motorways', the sports magazines prefer round-ups of all the possible places you might play golf, ride a horse or whatever their subject covers. All of this applies equally to magazines published outside the UK.

When looking for markets for your travel writing it pays to think laterally. Sports enthusiasts are not the only people who like to take holidays which will allow them to play in a foreign country; professionals also take holidays and for many of them attending something that could be considered to constitute professional research might just make the holiday a tax-deductible trip. Have you discovered a museum of dentistry in Bangkok or an agricultural machinery exhibition in Frankfurt? Try a query letter to dentists' and farmers' magazines. And do not forget the military magazines, especially those published for US and UN personnel and their families, such as *Off Duty* or *The Retired Officer*. If you know of something interesting within easy reach of a large military base it could be worth approaching these magazines. This is another of those situations where you can write about your own country as a travel piece for foreign nationals.

Nor should you forget that there are many British nationals living and working abroad. These may be expatriates permanently based abroad or migrants (or their descendants), but they often come back to the UK on holidays, and they also like to read about home at other times. There are several magazines published specially for expats, both for UK nationals abroad and foreign nationals based in the UK.

Another possibility is magazines for people who are think-
ing of buying property or a timeshare abroad; although
most of the articles in these magazines tend to be about
purchasing and maintaining property, there is still some
scope for articles about particular regions in appropriate
countries.

Finally there are magazines published by airlines, ferry
and cruise lines, car-hire companies and hotel chains. In
each case they want destination or shopping pieces which
feature locations connected with their activities. Pieces for
airline in-flight magazines should cover places close to the
airports they fly into; cruise-line magazines need items on
cities and ports where the liners call; car-ferry and car-hire
company magazines need items on routes to drive or places
you can visit close to their ports or office locations; and
hotel-chain magazines need features on cities where they
have hotels. Since many of these magazines are aimed at an
international readership, you need to be careful that you do
not refer to things which will puzzle visitor readers; for
instance comments about seeing Eddie Stobart on the
motorway will mean nothing to an American business
person who hires a car in England.

With magazines published by airlines, articles on places
in their country of origin will almost certainly be written by
people who live there but there are possibilities for you to
contribute pieces on other countries abroad as well as the
UK. You do not need to worry about translations as the
magazines which publish in other languages will deal with
this themselves.

Travel Newsletters

Newsletters differ from magazines in several ways. They
are never sold through newsagents, but only by

subscription. Few of them carry advertisements or photographs. They are much smaller than magazines (rarely more than twenty pages) and they are aimed at a very tightly defined readership. For instance *The Angling Report* details places round the world to fish, *Golf Travel* is for golfers who travel in search of the world's best golf courses and *The Educated Traveler* [sic] concentrates on learning experiences round the world, from cookery courses to lectures on illuminated manuscripts.

Because their target audience is so specific, travel newsletters do not have enormous circulation lists. Even the most respected and long established of the travel newsletters has a circulation of just over 10,000 (compare this with *France* magazine, which is now approaching the 70,000 mark). This means that their rates of pay tend to be on the low side, but also that you will not be competing with top-notch professional journalists to get your work published. Some newsletters will accept short filler pieces, such as travel tips or brief reports on good or bad things you have encountered in your travels.

There are a couple of these newsletters published in the UK, but most come from the USA. You may not find them in any of the usual writers' market listings, but the listing *Newsletters in Print* is available from the Gale Group (see the Appendix). They are also occasionally listed in travel magazines such as *Gourmet*. Otherwise it is a matter of asking other travel writers, especially those in Internet forums or chat groups.

You might even consider publishing your own newsletter. For details on this, see Chapter 10.

Short Pieces for Books

There is some scope for writing short pieces for anthologies,

and also to contribute to guidebooks. For details on this, see Chapter 2.

The Internet

This is a rapidly expanding market and one that no modern writer should ignore. You do not need to be a computer wizard to contribute to it; if you can send an e-mail, you can send an article. You do, however, need to be aware of how websites look and work, especially if what you are proposing is a new regular page rather than occasional contributions to an existing site. One of the major differences between print and electronic media is that while readers of print magazines will send a letter or telephone for details of something that interests them, electronic readers expect to be able to go straight to other websites at the click of their mouse, so you must give web and e-mail addresses. You also need to be able to tell the editors where they can obtain images to accompany your text, and these may have to be moving images, with appropriate music or other sound.

There are several types of opportunities for travel writers on the Internet. The first is the electronic equivalent of the travel magazines and newsletters mentioned above. The second is travel companies such as tour operators or airlines who have their own websites; although the main purpose of these sites is to sell holidays or transport, many of them like to provide some editorial content to encourage web surfers to stay on their site a little longer. As with airline in-flight magazines, your contributions should relate to what the site is selling.

The third is those companies who set up and maintain websites for commercial organizations who are not big enough to have their own web-literate staff. Many of these

like to have something extra to offer their clients and informed articles come into this category.

The fourth opportunity is the big Internet service providers like AOL or CompuServe, who need editorial content for their online magazines or 'communities'. Much like print magazines, these are a mixture of travel tips, round-up pieces and destination pieces. If you have ideas for these items, send an e-mail to the travel products manager at the head office, not the moderator of the travel forum or travel chat room.

The method of payment may be a straight fee per 1,000 words, or it may be a set amount per 'hit', where the service provider or website owner receives a fee every time your contribution is viewed. Do be aware, however, that many of the people who run small websites think that they should be able to obtain editorial content free and that they are doing you a favour by giving your writing what they call 'exposure'.

To locate the first three markets, do an online search for 'travel magazines', 'online travel magazines' and 'travel', but be prepared to wade through literally thousands of entries to find what you want.

Researching Markets

Remember the saying, 'If you don't read it, you can't write for it'? What this means is that your task when researching potential markets is not only to find magazines but to obtain copies of them, read them thoroughly and analyse what you read. You will find a good selection of UK-published travel and other magazines in larger newsagents but you may need to go at regular intervals as some do not retain copies on their shelves for more than a week.

Smaller-circulation and specialist magazines will not be

on open sale in newsagents and for them a different technique is required. The two standard works which are usually recommended for writers seeking markets (*Writers' and Artists' Yearbook* and *The Writers' Handbook*) are not adequate for this purpose as they are only published annually and only list a handful of magazines which use travel writing. The UK volume of *Benn's Press Directory* lists over a hundred magazines in its 'Travel and Tourism' category, but it too is published annually. Far better is *BRAD* (*British Rate and Data*), which lists more than 14,000 magazines, including well over 150 under 'Travel and Tourism' and many others which might take travel pieces, as mentioned above.

BRAD is published monthly and its intended readership is people who place advertisements in magazines, so it contains valuable information on the readership of each listed magazine, such as their socio-economic class. More details of this nature are available from the advertising departments of the individual magazines in a media pack, which will also include a recent copy of the magazine. Most magazines will send you a media pack if you phone and ask, although some may ask embarrassing questions about the type of advertisements you will be placing. The alternative to this approach is to telephone the editorial department and ask for their 'writers' guidelines' and a back copy. Some will send this straight away, others will ask you to send a stamped, addressed envelope for the guidelines or to pay for the magazine copy. Some, of course, will tell you that they do not use freelance contributors at all.

BRAD is not cheap; a year's subscription costs well over £1,000 (but you can buy a single issue for about £150), so you may have to go to your nearest library to consult it, unless you happen to know a friendly advertising agency. If you are serious about your writing, a day devoted to this task is well worth while, and as well as magazines in the

travel category you will find plenty of others listed under sports, motoring, military, or whatever your lateral thinking leads you to.

Another useful thing about *BRAD* is that it gives you the circulation figures and advertising costs, which are themselves a product of circulation size. The rule is that the higher the circulation, the higher the cost of advertisements. This gives you an indication of the rates of pay to contributors. The National Union of Journalists (NUJ) issues an annual booklet for freelances which shows recommended pay rates for the five standard bands of advertising cost.

All of this, in turn, tells you whether you should be attempting to write for any given magazine. Top rates attract top-quality professionals, and if you are not known to editors the first thing they do is look at your list of publication credits. Upmarket glossies will not take you seriously if all you have had published so far is a couple of articles in the *Borsetville Weekly Echo* or *Borsetshire Campers' Journal*. No matter how talented you are, you should not aim at the top. The best strategy is to start much lower down and gradually work your way up as you gain experience and credibility. Remember that editors have no obligation to encourage novice writers; their only concern is to put together a good magazine with the minimum of hassle.

For international magazines you need *Benn's Press Directory*, *Ulrich's International Periodicals Directory*, or *Writers' Markets*. Information on how to obtain *Ulrich's* is in the Appendix; *Writers' Markets* is available in bookshops. There are also several travel market lists available through the Internet, although they will not necessarily tell you anything that is not available from those listed above.

If your chosen magazines have websites you can check them out that way, otherwise you need to ask for writers' guidelines and a sample copy. Some may even send a copy of their publishing schedule, which tells you if and when

they are planning special issues covering one of the areas you know well. Send an International Reply Coupon when you ask for guidelines and another when you send query letters with topic suggestions.

If you have Internet access, you will find writers' forums and chat groups excellent sources of information. Not only will they know which markets take travel pieces and what sort of articles they like, they can also tell you about new ones starting, which have gone out of print, which have moved and where to, and what changes of editor have happened. Even more valuable, they will tell you which editors are difficult to work for and which are slow (or mean) payers.

How to Improve Your Chances of Acceptance

One of the things that mark the difference between novice and professional writers is that professionals know that each piece of work must be written for a specific market. When they want to sell another piece on the same topic for another market, they rewrite it for that market, paying attention in each case to the target readership, preferred length, opening and closing style, structure and even preferred paragraph and sentence length.

Novices tend to think that a single piece of writing, which has not been written with any particular market in mind, will do for any of the possible markets that have caught their attention. If you do this and have been wondering why you get so many rejections, this may be the reason. It is quite simple: the people who read *Hello* magazine are very unlikely to be regular readers of *Gourmet* and vice versa. Editors, who know exactly who their readers are and what they want, can instantly spot a lazy writer who has not bothered to do their homework on this.

So when you get those sample magazines and writers' guidelines you need to do some serious analysis of what you are seeing. Some, of course, will immediately strike you as not being your sort of thing and you can put them on one side. With the others it pays to develop some sort of system for your market analysis so you can see at a glance such vital things as preferred article length, style of writing, typical topics and so on. When you have been doing this for a while, you will find that when you see something interesting on one of your trips, instead of thinking, 'Oh, that's interesting, I'd like to write about that' you think, 'Ah, *Sagger Makers Bottom Knockers Journal* would be interested in that – but most potteries have a fixed annual holiday period, so I'd better find out if the dates are right.'

Some travel writers like to work out an itinerary for each topic. They get home from a trip, list their ideas, then go through their market notes and make a list of all the possible markets for each idea. Having selected what seems like the best market they send a query letter. Assuming that the answer is yes, they write the piece and send it off, then go back to their list to see where else they can send that particular piece without infringing the rights they have already sold and send copies of it to those. Then they consider how else they can treat the topic by rewriting it from a different angle for a different market, then send off more query letters.

What all of this means is not only that they keep up the impetus of marketing their ideas, but that they do not waste their precious research by restricting their writing to a single piece. Consider. You spend two weeks on a trip plus several more days on additional research before you go and after you get back, and spend a fair amount of money on both the trip and the research. Even if some of the trip was paid for by a tour operator or tourist office, you want to earn more for your efforts than the fee for one published

article. There is nothing unethical about this. Where you are selling a single, unaltered, article to several markets, you do so because you sell restricted rights to each one. Unless otherwise specified, it is the norm for UK publications to buy first British serial rights (FBSR) only, which leaves you free to sell rights to publish elsewhere: Australia, Canada, different countries in Europe and so on. You do need to clarify what rights are wanted in the case of those in-flight magazines or other situations where the publication will be available in several countries. In America, with regional newspapers and magazines, the norm is to offer each publication exclusive rights in their circulation area, which means that you can send copies of the piece to several publications simultaneously.

This is not the same as syndication. Syndication is the situation where you, or a syndication agency, undertake to supply a regular article to subscribing publications. Each publication pays a very small amount for the right to publish but these small amounts add up if sufficient numbers are involved.

When you reach the dizzy heights of working for prestigious, glossy international magazines, the situation is different. These do not like the risk of bias which they feel could come from free trips so they pay your expenses as well as an agreed fee for your writing. Having done this they usually feel that they are entitled to exclusive rights on your experiences, whether in the form of the words they publish or other forms, and your contract with them will place restrictions on what you may or may not write for anyone else. Sometimes this is an absolute ban, sometimes it is a time restriction: six or twelve months after they have published your piece.

Now that so many publications have websites and publish simultaneous print and electronic versions of each issue, they will also want electronic rights. Obviously you

should be paid more for these, since it effectively stops you selling the same piece elsewhere. The very nature of the Internet is that it is a world-wide medium.

All of that relates to reselling unaltered material (adding different opening and closing paragraphs but leaving the middle unchanged comes into that category). Quite different, unless you have one of those contracts which forbids it, is writing a different article from your experiences on one trip and one set of research material. When you consider the very different readers of various general magazines – age-band, socio-economic class and leisure pursuits, even before you start looking at specialist magazines – it is obvious that any given place or situation must offer a whole sequence of different articles.

Any decent-sized town anywhere in the world has at least one museum or art gallery, some old houses, some fine places of worship, some interesting history, at least one annual festival, a special local product or locally grown produce, a local cuisine, some famous people and many other interesting things. Each of these can form the focus of a separate article.

One of my happier discoveries was the sculptures and other works of art on motorway rest stops in France. The first we found was a rest area with a children's playground made entirely of toadstools. Swings and climbing frames, slides and stepping stones, the picnic tables and stools and the rubbish bins are all authentically shaped and painted as various fungi. Even the toilets are housed in giant toadstools. A query to the French Tourist Office led to the company which builds and maintains the motorways; they told me they have a policy of providing interesting features at their rest areas to encourage drivers to take a proper rest from driving. At other rest stops they have created walls made of mirrors and glass, windmills, various sculptures and a full-scale archeodrome with replicas of archeological sites in the region.

So far I have sold articles on this to two motoring magazines, one to *France* and one on the Internet. In the pipeline are others for a parenting magazine, more motoring magazines and some newsletters.

One of the first two motoring magazines (both culled from a perusal of *BRAD*) turned out to be a new experience for me. Coming into a category known as 'advertisement led', it was like a free newspaper in that copies were sent free to the owners of a particular make of car and all the revenue came from the advertisements. The idea of using articles for which they had to pay was new to them, as they had previously only printed advertisements and 'advertorial' (those short pieces written about specific products or services which were being advertised).

None the less, they did print the article and pay for it, then suggested that future contributions should be accompanied by (paid) advertisements from companies mentioned in the text, which would provide them with funds to pay for the articles. On the basis that I am not an advertisement salesperson, I turned this suggestion down, but subsequent copies of the magazine showed that someone had obviously accepted the suggestion, as a series of hotel and restaurant reviews appeared, duly accompanied by advertisements for those establishments.

Advertorial itself is usually written by copywriters commissioned by the advertisers, but it is not unknown for them to pay travel writers to write it for them. The styles of writing used by someone who is used to writing advertising copy is not always suitable for what is meant to read as an unbiased report from an outsider. The type of magazine that uses advertorial does so because it does not have to pay a writer for it, and they like it even more if they do not have to pay someone on their editorial staff to lick it into shape. With a carefully worded letter, or a delicate approach when you are on the spot, you might be able to

pick up some commissions from companies who send out advertorial and press releases.

Approaching Markets

One of the reasons novice writers often think it would be nice to have an agent is that they do not like having to sell their ideas to editors. Most professionals do not much like having to do it either, but they know that it is an essential part of the job. (Note that until you are in the position of earning several thousand pounds a time for your writing, no agent is likely to take you on. See pages 53–4 for more on agents.)

You have to understand that a piece of writing is a commodity, and like any other commodity it has to be made attractive if it is to sell. But just as a potential purchaser of any item expects to have an idea of what is offered before they inspect and handle the goods, editors want to know what you are offering will suit their publication before they have a close look at it. So you have to write a sales letter first.

You should not send unsolicited writing, even accompanied by a brilliant sales letter. In the eyes of editors, sending unsolicited articles is the act of rank amateurs who cannot be bothered to read the many books on writing which tell them not to do so. On a good day, if you have sent a stamped return envelope they will just return it; on a bad day they will just drop it straight in the bin, stamped envelope and all. Your article might be written in exactly the style they like, on a topic they have not published before, but they will not bother to look at it to find out. They get dozens of these things every week and they know from long experience that so many of them will be hopeless it is not worth the time it would take to sift through them all in the hope of finding something worth using.

That sounds incredibly brutal and callous, but it is a fact of life. Any form of writing is intensely competitive and travel writing is even more competitive than most other genres. If you want to be a successful travel writer, you have to adopt professional attitudes and do what the editors want and what the professionals do: start by sending a query letter.

A query letter is basically one which says, 'I have had an idea for an article on so-and-so, would you be interested?' but of course it needs to say a lot more than that. It can either start with the question 'Would you be interested in an article on so-and-so?', then go on to give some detail on why the topic is interesting, with a brief outline on how you would tackle the idea, or it can start with a statement about the interesting topic then ask the question and add the outline. It should read something like this:

Dear Ms Bloggs [always the name of the editor, never 'Dear Sir' or worse, 'Dear Sir or Madam' – couldn't you be bothered to find out the editor's name and spell it properly?]

Next September, Florence will host the 429th International Flamenco Festival. For six days, teams of flamenco dancers will perform and compete for the prestigious Sevillana Cup and the ten million pesetas prize. Hotels are offering special rates to *aficionados*; other events with a Spanish flavour will include mock bull fights with stuffed bulls on wheels and pantomime horses, while restaurants and bars will be offering a full range of tapas and Spanish wines.

Would you be interested in an article on this topic? Provisionally entitled 'If this is Florence, why are they dancing flamenco?' [not 'Flamenco fiesta in fabulous Florence', alliteration is another mark of the amateur], it will give a brief history of flamenco dancing, mention the winning teams from previous years, suggest good hotels and

restaurants and detail some of the classic dishes on a tapas menu, the whole in 800-1,000 words [obviously this length will be the same as their norm].

I enclose some copies of my published work to give you an idea of my style, but of course this piece will be written with your readers in mind [this says 'I'm not a beginner and I know what you want'].

Yours sincerely

Henry Higgins

If you do not have previously published travel writing to show, omit the last sentence and replace it with a simple 'I look forward to hearing from you.' Certainly you should not mention that you are as yet unpublished.

A query letter like this does a number of things. It allows editors to tell you they already have a piece on your suggested topic in stock, published something else on flamenco or Florence a few months ago, or just do not think it is right for their readers. It also, and this is more to the point as far as the editor is concerned, says that you have done your homework and know the length and type of article they like, and will be including what is relevant while omitting what is not (such as tangential information on the best art galleries in Florence).

You should, incidentally, only cover one idea in such query letters. Until you have written several pieces for any given magazine, listing several ideas gives an air of desperation, or worse, looks like a take-over bid.

Your proposals do need to be as detailed as this, and to have a specific theme. Asking if an editor would be interested in an article on Germany, or even Frankfurt, will not do; these are places, not ideas, which is what editors want to see. 'Frankfurt, conference capital of Europe' is an idea, especially if your outline mentions some of the industries that hold annual events in the city before moving on to

what entertainments are offered for conference attendees in the evenings. (This idea obviously is not suitable for consumer magazines but could be sent to the trade journals of any of these industries.)

Your timing has to be right, too. If you hope to write about a specific event which readers might want to attend, your queries need to go out almost a year in advance. All magazines have what they call 'lead time', the time it takes between sending the completed material to the printers and the finished magazine appearing at the newsagents. Then the readers need to have it at least a couple of months before the event to allow them to book tickets and hotels. And you need time to write it, even after you have had a favourable response from the editor, which could itself take several weeks. Even if the topic of your article is not related to specific dates, there are other considerations that could make it time-sensitive: items on winter sports are usually published in December, summer holidays in January or February.

Remember also the vast numbers of people who decide they want to visit a place after seeing it on film or television. The film *The French Lieutenant's Woman* caused a boom in visits to Lyme Regis. When *Wuthering Heights* is dramatized on TV, there is renewed interest in the Yorkshire Moors and the Brontës' home at Haworth.

Since these films and classic TV series are shown world-wide, there is scope for selling articles in travel magazines throughout the world. Other types of TV programme, natural history and art documentaries, also focus the public's attention on their subjects; travel articles on gorilla-watching trips have become commonplace since David Attenborough was shown romping with young gorillas, and an enterprising writer sold a piece to the *Mail on Sunday* about the Dinosaur National Park in Colorado to coincide with the screening of the series *Walking With Dinosaurs*.

31

The making of all these programmes and films is announced well in advance of their screening, so if you keep your eyes open for such news you should have plenty of time to do some preliminary research and get your query letters out. The BBC also makes regular announcements about programmes which have been sold overseas, which should give you the chance to get letters off to appropriate publications abroad.

There is one bad time to send query letters: September and early October, when many people who think they would like to write about travel have just got back from their holidays. Editors' postbags overflow then with unsuitable suggestions and unsolicited manuscripts, so you might do well to avoid those times.

Whenever you send your query, it must be in writing. For print media it should be a letter, unless it is a hot travel news story, in which case a fax is permissible. For the Internet, it must be e-mail. Until you are well known to an editor, it should never be a phone call. The point is that what you are trying to sell is a piece of writing and your ability to talk on the telephone does not show whether you can write. A good query letter and outline does.

However persuasive your query letter and outline, unless you are already well known to the editor, it is unlikely to bring a definite commission, but a 'Looks interesting, I'd like to see the finished piece' is a step in the right direction. So now you have to write the article and send it off. Some travel writers believe you should respond to this interest by sending an interim letter thanking the editor for his or her interest and confirming that you will be sending the finished article shortly, with an indication of when that will be. You do not need to do this if you can get the article in the post within a week, but otherwise it is a good idea to send a reminder of your name and idea.

Then, when you do send the article, attach a letter which

says 'This is the article on so-and-so which you asked to see', which will prevent it being dumped on the unsolicited pile. Hopefully what happens next is a letter saying, 'We like your article, we'll be using it in such-and-such edition.' With some publications, this letter will be accompanied by a contract form which you have to sign and return, and in due course you should receive a copy of the magazine and eventually a cheque. Check the contract form to see whether you need to send an invoice and what rights the magazine is buying.

If you get the letter but no contract form, it is acceptable to ring the editor for a quick businesslike conversation. Ask whether you need to send an invoice and to whom, what rights they want and how much they will be paying. If it does not sound like very much remember that when you are starting out you are not in a position to demand top rates. As a beginner, it is more important to collect some publication credits, even if to do so you have to accept peanuts and part with all rights.

Even with Internet work you should have a proper letter of acceptance and/or a contract note, not just an e-mail. There is an interesting legal point here: whether anyone who has the capability to send e-mail from a company has the authority to commit the company to paying for goods and services ordered by e-mail.

Internet work can be sent as a simple e-mail or as an attached file. When sending work on disc, do not forget to put a label on the disc with your name and address and the crucial details of the article: its title and length. For work on paper, the usual rules apply: use only one side of standard white A4 paper, double-space your lines and put your name, the title of the piece and page numbers on every sheet. Do not use fancy fonts or jokey computer graphics, and make sure the print is dark enough to be read easily. It *must* be a typescript; handwriting, no matter how beautiful,

will lead to instant rejection, as will pale dot-matrix print. Some publications stipulate that dot-matrix print will not be accepted at all. If sending work to overseas publications, check their preferred manuscript style. Most magazines here like letter style (no indents for paragraphs, extra line-space between paragraphs), whereas in the USA, some (but not all) like indented paragraphs and no extra line space.

Finally, when you do reach the stage of having work commissioned before you have written it, make sure that you deliver it on time. There are few acceptable excuses for missing a deadline; your house burning down, a serious car accident or a death in the family perhaps, but anything less, or a second occurrence, and you will be labelled unreliable and the commissions will dry up.

Should You Ever Write for Nothing?

Professional writers will always answer this question with a resounding 'No!', on the basis that a professional worker is worthy of their hire and only works for the money anyway, that it downgrades the value of everyone's writing if some of it can be had free and that since editors are not doing *their* job for nothing, only a cheapskate expects to get their content free. So, in principle, you should not write for no pay. However, there are a couple of situations when you might consider it.

The first is when you are starting out and have no publication credits or cuttings to show. Having none does not make it impossible to be published but it does make it that much more difficult. Editors like to be reassured that you can produce a decent piece of work before they commission you or even spend their time reading what you send in, so sending copies of two or three of your recent pieces sets their mind at ease. These clippings and credits are also

helpful when you are seeking assistance or facilities from travel companies, tourist offices and individual attractions on your trips.

The other situation is when you have received hospitality from such organizations but cannot interest any editors in paying you to write about them. Of course, you should not accept such hospitality unless you are confident you can repay it with the published piece that is your side of the bargain, but sometimes it just happens that way. Suddenly the destination does not appeal to the mainstream publications, or the event you went to observe just was not exciting enough. Your hosts are not concerned with whether you have been paid to write, only that something is published. Since it is on the Internet that you are most likely to encounter non-paying situations, it is these websites that you should approach in the first instance.

2 Travel Books

Something like 2,500 travel books are published each year in the UK alone. Many of these are updated versions of long-standing guidebooks, but many more are new publications. There are also numerous books which can be considered travel books but which publishers and booksellers categorize as business, cookery, gardening or sports.

For the new writer who takes a long time to complete and polish a 1,000-word article, the thought of tackling a book of 50,000 words or more is daunting. But if you can write one 1,000-word piece in a week, you can write a 50,000-word book in a year (much less, actually, as it gets easier with experience and practice). It is like eating an elephant; you just keep on making the sandwiches and eating them one at a time. There are also some situations where you can contribute part of a book without having to do the whole thing. This applies mainly to guidebooks and accommodation guides, but some publishers also produce anthologies of travel writing and will accept new writing for these.

Any good bookshop will have a travel section, but for a really comprehensive selection you need to visit a specialist shop such as the Travel Bookshop in Notting Hill, or Stanfords, who also have a website on *www.stanfords.co.uk*. Stanfords started out as a map shop and they are still the

one who does not expect to write full-length books, should make an opportunity to visit one of these specialist shops just to see what is being published and by whom. For those who intend to write travel books, visiting these shops is an essential part of market research.

Now for a look at the different types of travel books.

Guidebooks

This is an enormous genre, ranging from the big-name series of annually updated fat books which try to cover everything in a country, to the very specialized, which cover one tightly defined aspect of an area (e.g. *The Roman Remains of Southern France*) or which cover a small area only (e.g. the *Hidden Places in Britain* series, each of which deals with one county only).

The general guidebooks (Lonely Planet, Frommers, Blue Guides, Baedeker and all the others) are a vast industry in themselves. You only have to glance at the content to realize that they must be produced by a team of writers; no one individual could possibly visit every listed place in every listed town. This is not always clear from the credit pages and the trend now is to emphasize the brand and play down the individual contributors. Most of these guidebooks are updated every year, and although some contributors continue year after year there are inevitably some dropouts, leaving spaces to be filled. If you have detailed knowledge of a particular area, or are prepared to put the time into checking it out, write to the editor of the relevant guide and volunteer your services. It may be easier to break into travel writing this way than by starting with magazines and it does give you a distinct edge to be able to list a guidebook contribution in your publication credits.

Payment amounts and methods vary from publisher to

publisher, but in all these cases you will receive a flat fee for the job rather than royalties. Some publishers pay expenses only, one or two are notorious for exploiting gap-year students, some pay a single fee to the editor and the editor pays the individual contributors. Although it is not generally admitted, it is apparently common practice for editors to sub-contract work. For more details on how different publishers pay and other insightful information on guidebook writing, you might like to consult the two websites *www.infoexchange.com* and *www.guidebookwriters.com*.

The general consensus of opinion is that this sort of guidebook writing is poorly paid for the time and effort it involves. However, unless you are being paid for exclusivity (unlikely, as most guidebook content is pure fact and thus cannot be restricted), there is no reason why you should not write articles on interesting aspects of your research, or even, if you can organize it, contribute to more than one guidebook at a time.

If you have in-depth knowledge of an area or country that is not covered in a particular publisher's series of guidebooks, you can write and suggest doing one for them. You will have to give them sufficient information to convince them that there is enough material for a book, and you will also have to produce some statistics to demonstrate that people are actually going to the place in sufficient numbers to make the book a financially viable proposition. You will have to have a good idea of how long it will take you to do the in-depth research and what your expenses will be; for a new guidebook like this you may be offered a flat fee or royalties, in which case you will need a decent advance to fund your travels and writing time. Whichever way the payment works, you will want a contract which prevents the publisher giving your baby to another writer in the future; once you get to that stage in the discussions it might be wise to find an agent to take over the negotiations.

For a new guidebook concept (*The Flamenco Aficionado's Guide to Western Europe* perhaps, or *Tuscany for Tricyclists*?), you will have to provide potential publishers with a structure for the book as well as an indication of the market and material available. You will also have to decide what to include in the way of maps and itineraries and whether photographs are essential. Given that the trend in new guidebooks is towards the specialized rather than the general, there are real opportunities for any writer who can spot a good guidebook niche.

Although the structure of your new guidebook is something that will have to be decided between you and the publisher, there are some conventions you should not ignore because readers are used to them. For instance, it may seem to you that strict alphabetical order of towns would be a good idea, but readers will not like it when they are trying to work out where to go next or if they can get from one town to another before the museum closes. It is better to stick with the convention of grouping towns into regions, and to delineate these regions in the same way as the area's administration and map-makers.

Another trend in guidebooks of all sorts is to put specialized information in boxes; if your general text covers the history of the town, you would have a box listing the opening times of the museums and another listing the restaurants near the museums where you can have lunch. If the town includes a famous author amongst its previous inhabitants, a box would give a brief biography, list their best-known works and mention where the grave can be viewed.

Accommodation Guides

Aimed at the independent traveller, these come in three main types. The first are those like the Michelin guides,

where the listed establishments cannot apply for inclusion but are only added after rigorous anonymous inspection by the publisher's team of professional inspectors, and which can be removed if their standards fall. There is little scope for the average writer to join these inspection teams.

The second are those guides which are just listings of the members of a commercial trade association such as Logis de France. The members (hotels and private homes which provide bed and breakfast) normally pay a fee for the services they receive from the association, which includes an entry in the guides. The listings are a compilation of basic information such as number of rooms, price band, facilities available and opening dates. There is almost no scope for the average writer to work on these guides.

The third type is private listings of establishments which may or may not be listed in the other guides. Most of these cover B&Bs, but others cover 'small country inns', pubs with rooms to let or very upmarket B&Bs in stately homes. Some, but not all, ask listed establishments to pay a fee for inclusion, but only include places which have personal recommendations. Some are the recommendations of the authors, some will accept suggestions from readers and inspect before including them. The entries are much friendlier than the collection of abbreviations and symbols in the first two types of guide and usually include some personal details of the proprietors. A typical example of this sort of guide is the series published by Alastair Sawday.

There is a good chance of your joining the inspection teams for this type of guide and good possibilities for suggesting new titles to fill gaps in the series. Again, the trend is towards the specialized rather than the general guide, with accommodation and meals for particular groups of people proving popular; think of dog-owners, people touring on bicycles or people with young children.

Motoring Guides

Typical of these are the books in the 'Back Roads' series, which offer a sequence of routes through the featured country which avoid the main roads. The individual routes have to be quite detailed, with road numbers and instructions on where to turn, and they are normally circular routes which can be driven in a day with time allowed for a leisurely lunch or picnic. Good picnic sites and restaurants are mentioned, often in boxes. Some of these guides also include a brief run-down of the country's motoring regulations and a couple of pages of useful phrases such as 'Is it all right to park here?' or 'I have a puncture.'

If you can see a gap in a series you could make a proposal to the publisher, keeping in mind that the main targets for these guides are drivers who take their own cars abroad rather than those who hire cars when they arrive. This does rather restrict the possibilities to those countries which are within easy reach of ferry ports served from Britain. However, just because there are already several motoring guides for a particular country it does not mean there is no scope for another; if all that is available is a general guide, think of the possibilities of following a great river from source to sea, driving along a mountain chain or following a route associated with a historical personality.

Other Route Guides

For every reader who wants to motor through the picturesque areas of a country, there are others who want to do it on foot or on a bicycle. Like motoring guides they consist of specific routes to follow, but these do not have to be circular, as uninteresting parts of the journey or the return to base can usually be accomplished on public

transport. In this case you will have to give an indication of bus or train timetables. The route maps you give need to be much more detailed than those for motorists, or you can recommend specific commercially available maps which will do the job. As with motoring guides, the best chance for a newcomer is to spot and offer to fill a gap in a series.

Traveller's Health

There is little scope for writing a handbook on this topic as there are several in print already and the classic, *Travellers' Health* by Richard Dawood, is now in its third edition. Described as a comprehensive guide to everything from AIDS and Lyme disease to how to cope with poor hygiene and sanitation, it really does cover everything even the most confirmed hypochondriac needs to know. And yet, as with all general guides, the existing books do leave scope for more specific titles; perhaps there is room for an asthmatics' guide to the Far East, or a guide to the best places to go for private surgery. However, unless you have a medical qualification or a lifetime's experience of the affliction named in the title, you will have difficulty persuading a publisher that you are the right person to write such a book.

How To Find Work Abroad

There are several series of books which cover this topic, including those from How To Books and a series of 'Living and Working in ...' from Survival Books. How To Books have a policy of only using authors who have many years' experience of working in the field on which they are writing; for instance the author of their book on obtaining visas for Canada was an immigration official for the Canadian

government. The Survival Books series is extremely comprehensive; each book comprises 500 pages or more of very detailed information, from obtaining a visa and getting a job to everything you need to know on setting up home and living in each country, including the voltage requirements for electrical equipment and the best way to get your children educated. This series is now complete but does have to be updated every two or three years, so if you have such detailed knowledge of any of the countries you might volunteer your services. The publishers of other similar series might also be interested in assistance on updates.

As well as books on living and working in specific countries, there are several on more specialized topics such as finding vacation or au pair work abroad. These also need regular updating, as various governments tend to change the rules frequently on what occupations can be undertaken by students or other temporary workers.

Buying and Renovating a Home Abroad

The recent boom in books on this subject was fuelled by the runaway success of Peter Mayle's *A Year in Provence*. People read it and realized that their vague ambition of living abroad was not just a dream, and there has been a spate of books to help them realize that dream. Some of these books concentrate on the legal aspects of purchasing property, others on what you need to know when you have bought a tumbledown house and want to turn it into a desirable residence without too many battles with the local builders.

Survival Books has a series called 'Buying a Home in ...' which are as detailed as the 'Living and Working in' series. Many other general publishers have individual books on both buying and renovating houses in specific countries.

The countries on which books are available follow fashion; there are many on France (probably so many that no publisher will look at another), quite a few on Tuscany and no doubt there will soon be lots on Spain after the success of *Driving Over Lemons*, in which former pop drummer Chris Stewart describes his experiences in rebuilding a country house in Andalucia. If you have the necessary legal knowledge or the actual experience, this topic is a possibility.

Business Travel

From Mark McCormack's *Hit the Ground Running – The Insider's Guide to Executive Travel* to Roger E. Axtell's *Gestures – the Do's and Taboos of Body Language Around the World*, these books are for people who travel on business and need to know how to get around efficiently and how to deal with foreigners without offending them. (*Gestures* would be a useful addition to any travel writer's reference shelf.) At the time of writing, a rumour has reached me that one particular publisher is planning a series of 'Doing Business in ...' books which will deal with both local practices and local regulations in the relevant country; keep an eye on the bookshops for the first of these and consider whether you have sufficient knowledge to contribute to the series. Otherwise this is a very specialized market that requires considerable experience of travelling on business.

'Coffee Table' Books

These expensive books are often spin-offs from television series such as *Great Railway Journeys* and as such are written by the people who made the series. Others are basically

collections of superb photographs with a connecting narrative; if you happen to know a talented photographer you might collaborate on one of these books. Otherwise there is little scope for a newcomer.

Autobiographical Tales

These stories of an individual's journey are those which the average person considers to be travel writing. Authors whose names spring to mind in this connection are Colin Thubron, Dervla Murphy, Eric Newby, Tim Severin, Paul Theroux and even Thor Heyerdahl. All are compulsive travellers; some like Colin Thubron seek the soul of their topic country, some like Tim Severin and Thor Heyerdahl seek to replicate epic journeys. Others, like Eric Newby and Dervla Murphy just like to see different places and different people. For all of them the journey is the thing and the writing about it comes second, even though they hope the proceeds of the book will pay for the actual journey. Often the fact that they have obtained a book contract makes it possible to get sponsorship and other practical assistance.

But it is very, very difficult to get either a book contract or sponsorship until you have a track record or unless you are already famous for something else. So you will have to fund your first journey yourself and write a substantial part of the book before you can interest a publisher in the idea. A little basic word counting in a library or bookshop will soon tell you that this sort of travel book usually runs to more than 100,000 words – a task that will take even an experienced writer the best part of a year. If your first book is not a financial success for the publisher, you will never sell another.

Nor, unless your experiences have been spectacular and unusual (your bathtub boat sinking as you finally sail into

Sydney Harbour, or the accidental discovery of a lost city as you walk across the Sahara), can you get away with anything other than really good writing. A writer with the literary equivalent of the bad singer's 'tin ear' can make even a journey by dugout canoe down crocodile-infested rivers seem boring. Good narrative travel writing is not just telling where you went and what or who you encountered; to recount a journey so that your readers really feel they are sharing it, you have to include your innermost thoughts – not just what someone looked like but who they reminded you of and what effect that person had on your life. Why are you so interested in a certain type of animal or bird? What were you told about them as a child that makes them so fascinating now? How does what you are seeing compare with what you expected after your reading of the country's classical literature?

Are you making the journey because of an obsession, or because it turned into a pilgrimage for you? Simon Winchester describes his book *The River at the Centre of the World* as 'a journey up the Yangtze, and back in Chinese time'. After twenty years as foreign correspondent for the *Guardian*, he is now the Asia-Pacific editor for *Condé Nast Traveller*. For many years he had had a vague ambition to write about the Yangtze River but it was not until he was shown an ancient hand scroll painting of the river, over 16 metres long, that his vague ambition crystallized into something he had to do straight away, as he saw that the river effectively encompassed 5,000 years of time from its source in remote Tibet to the industrialized areas round its mouth near Shanghai.

This sort of travel writing takes time to organize the journey (no mean task in itself in some places where the bureaucracy is particularly obstructionist), make the journey and write it up afterwards. It takes money to equip and feed yourself, pay for the journey and pay your living

expenses while you write. It takes a considerable sense of humour to keep going when you are lost in the middle of nowhere as night falls and the third thunderstorm of the week approaches. And above all it needs stamina and good health; something that you can shrug off at home with a visit to the doctor and a handful of pills could kill you in the Burmese jungle.

All of which is not to say that it is impossible to write and publish such a travel book, merely that it is not something that a newcomer to writing should seriously contemplate until they have some experience behind them.

Humorous Travel Books

Some of these, such as Peter Biddlecombe's *I Came, I Saw, I Lost my Luggage*, are collections of stories about amusing incidents which have occurred to the author over a lifetime of travel. Others are travellers' tales like those described above, viewed with a keen sense of the ridiculous. Bill Bryson comes into this category; he has an outlook which notices life's incongruities and the silly things people do, plus the ability to report all this without being cruel. More recent newcomers to this field tend to be already established as prose humorists or performing comics who have now turned their attention to the humour that can be got from travelling. Some even start their journeys with a running gag built in, such as Tony Hawks' *Round Ireland with a Fridge*. While he was in Ireland for a song contest he saw a young man trying to hitch a lift with a fridge and made a bet that he could hitch all round Ireland with a fridge; his book is the story of that trip.

Like many other types of travel books, it is difficult to enter this field without some sort of track record; publishers know full well that even without the fact that one

person's hilarious joke is another person's big 'So what?', humour is one of the most difficult of all types of writing.

Psychology of Travel

The big question of why people want to travel is one which is always worth examining. The premise behind Bruce Chatwin's *The Songlines* is that a nomadic wanderlust is humanity's natural state and he pursued this theme by travelling round Australia in the ancient aboriginal tracks.

Another recent success of this sort is *Into The Wild* by Jon Krakauer, the true story of Chris McCandless, a young man who abandoned his education and family and went off into the wilderness to pit himself against nature. After narrowly escaping disaster going down the Colorado River in a canoe, his final trip was to Mount McKinlay in Alaska without proper equipment, food or even adequate knowledge of edible plants, but a firm conviction that the turgid writings of his hero Jack London (who himself spent only one winter in the north before returning to his comfortable home in sunny California) showed an ideal life in the wilderness. Leaving notes stating 'I go now into the wild', McCandless hitch-hiked to the foothills of the most dangerous mountain in North America and disappeared. His body was discovered by chance several months later; he had starved to death.

This sort of detailed journalistic exercise, while not that easy to place with a publisher, will always find a home as long as the story it tells is interesting and it draws some worthwhile conclusions about the human condition.

Food and Wine

One of the major delights of foreign travel for many people

is the opportunity it gives them to experience different cuisines. This is partly catered for by restaurant guides, but also by books such as Glyn Christian's *Edible France*, which is a region-by-region guide to food, wine, shops, markets and local specialities. Other food books include *Tuscan Food and Folklore* and a series of 'Self-catering in ...' books with advice on what to buy and how to prepare it. These books may be published by cookbook publishers, or will be found in the cookery sections in bookshops. Elisabeth Luard, who wrote the classic *European Peasant Cooking*, wrote a follow-up book (*Still Life*), describing the adventures of her and her husband as they travelled round Europe while researching the cookery book. You may find this categorized as travel or food.

The trick with food-related travel books is to watch restaurant trends in British cities. When there is a lot of interest in a new national cuisine (Thai food, Italian food, tapas bars, etc.) people who eat in these restaurants want to sample the real thing in its country of origin, and that could be your chance to sell a book idea to a publisher.

Anthologies

Most anthologies of travel writing tend to be an editor's choice of previously published writing or pieces specially written by well-known personalities, such as *The Travellers' Handbook* edited by Miranda Haines. Contributors to this book include Chris Bonnington and Ranulph Fiennes, and the contents include tips on surviving a kidnap or hijacking, what to do when war breaks out, and comments like 'Freshwater swimming is not advisable where there are crocodiles or hippopotamuses in the vicinity.'

There are, however, some small publishers who specialize in anthologies of new travel writing. A good example of

this is the American publisher Travelers [sic] Tales Inc. (see the Appendix for their address), who actively seek contributors. Their books include a series on various countries, some on travel for women, and others such as *The Fearless Diner – tips and wisdom for eating round the world*. Their guidelines for writers say that stories should 'reflect that unique alchemy which occurs when you enter unfamiliar territory and begin to see the world differently as a result'. They accept anything from a dozen words to a dozen pages.

You may be wondering why some of the categories of travel books above have been included, when the basic message is 'not much chance'. They are there as an indication of how wide the field is, and to start you thinking and extrapolating on what topics might be possibilities for you. Get into the habit of checking the travel shelves in a good bookshop and keep an eye open for new trends. Not only does the public's taste in types of holiday change, so does the world political situation. Some countries loosen up and seek tourist money, for instance China and many of the satellite countries of the former USSR, while others break down into war and become no-go areas for a few years. With these latter countries, by the time the situation changes and they are safe to visit again, the existing guidebooks will be out of date and new ones will be needed, thus providing another opportunity to an alert writer.

Selling a Book Idea to a Publisher

Just as you have to sell an article idea to a newspaper or magazine with a query letter, once you have worked out what it needs to contain, you have to sell a book idea to a publisher with a proposal.

This should consist of several parts. First is the proposal itself, which basically says 'this is a proposal for a book on so-and-so, provisionally entitled "The Road to Wherever-it-is" by Jane Bloggs', then goes on to give a brief (no more than two lines) statement of what the book is about ('The sights to be seen on the road from Here to There'). Then another brief paragraph says what the content will be ('All places of interest will be described and the route itself will be shown on a series of maps. Hotels and restaurants will be recommended and there will be a glossary of local terms and some useful phrases with a phonetic pronunciation guide').

The next paragraph says why you believe there is a market for this book ('In the last three years, the number of visitors to Whereland has increased by 800%') and mention any competing books ('There are no up-to-date guides to Whereland, the last having been published in 1976' or 'There are only two existing guides to Whereland, one very slim volume about medieval churches and one general guidebook issued by the Whereland Tourist Office, which is only available in Whereland itself').

Finally you say what your qualifications are for writing the book ('Jane Bloggs has been travelling to Whereland for the last twelve years and has an extensive knowledge of its railways and roads, as well as tourist attractions and other sights').

All this should occupy no more than one sheet of paper.

The next sheet should be headed with the title, a few descriptive words ('A guide to Whereland by Jane Bloggs') and a couple of paragraphs describing the book in the terms you would expect to read in the jacket blurb, something like this: 'Jane Bloggs has been a regular traveller to Whereland over more than a decade and now she shares her knowledge of this charming country and the delights to be found along its historic rural routes ...'

The next sheet should be headed again with the title and the words 'A synopsis for a book by Jane Bloggs' and then give a simple list of chapter headings (1. Introduction. 2. History of Whereland. 3. Whereland's Cooking ...), ending with 'Appendices, Glossary, Useful Phrases in Whereish, Useful Addresses, Index.'

Then on further sheets you should supply further details of each chapter, devoting a couple of paragraphs to each.

Finally, there should be an accompanying letter which says, very briefly: 'Please find enclosed my proposal for a book on Whereland, which I believe would fill a gap in your "New Places" series/be a valuable addition to your travel list. I have a sequence of maps available for use to illustrate the routes and also a large collection of colour transparencies. I will be happy to provide a sample chapter if you wish.'

At this point, if you have an impressive number of publication credits, you can mention that you are including a sheet listing them, with a line in the letter that says, 'I enclose some details of my previous publications.' If you only have a few you can say, 'I have previously published a number of articles in *This and That* magazine on Whereland and other travel topics.' If you can't do either, say nothing. Then end with a simple 'I look forward to hearing from you.'

It is much better to send a businesslike proposal of this sort than to write the whole book and send it. Unsolicited manuscripts get added to what publishers call the 'slush pile', where they sit until someone gets round to looking at them, which can take many months. Some publishers refuse to accept unsolicited manuscripts and send them straight back unread. And since, as with magazine articles, travel books need to be written in a way that suits the individual publisher (especially where series are concerned), you do not want to waste all the time and effort it takes to

write the book for that publisher if the response is 'No thanks'.

What Happens Next

With small publishers, where the editors are often also the owners of the business, you will get a fairly quick response. With a larger publisher, where everything has to go through a formal routine of readers' reports and commissioning committees, it will take several weeks. Of course, if the editor you have sent it to does not like your idea, or there is already something similar in the pipeline, they will probably say so pretty quickly; you then shed a few tears or snarl at your spouse, rewrite the proposal for the next publisher on your list and send it out again.

If the editor thinks it is a possibility, it will be sent off for a readers' report. If the first reader hates it but the editor really likes it, it will go to a second reader. The editor may pass the reader's comments on to you and give you the chance to modify your proposal accordingly. At some stage in this process you will probably be asked for a sample chapter or some sample entries if it is a guidebook. At the end of all this, with good readers' reports, the proposal will be submitted to a commissioning committee and assuming no one on that committee hates the idea, it will be accepted and you will get a letter with the good news from your editor.

Up to this stage, you can do everything without an agent (or you can with most British publishers and some American publishers). You can do all the rest of it without an agent too, if you want, but if you are nervous about negotiations and contracts you might seek an agent to deal with this for you. For detailed information on what agents do and how to choose one, see Michael Legat's book *An*

Author's Guide to Literary Agents. Michael Legat has also written *Understanding Publishers' Contracts*, which you will find helpful if you decide you do not need an agent. Both books are published by Robert Hale. You can also, once you have received an offer to publish and a copy of the contract, ask the Society of Authors to look at it for you. The Society will not negotiate on your behalf, but it will point out any problematical areas and offer advice on how to proceed.

Book Contracts

Sometimes these are called 'agreements', but they are the same thing: a formal document which sets out the terms on which the book will be published and how you will be paid (and when). A date by which you have to deliver the full text of the book will be given as well as a publication date. The fee or royalty arrangement will be stated, with a list of what rights the publisher is acquiring. There will be many other clauses, and the whole thing will run to several pages. Alas, there is not enough room in this book to detail all the possible clauses you might encounter.

Finally there will be spaces for signatures.

If you are not using an agent and there is anything you do not understand in the contract, ring your editor and ask for an explanation before you sign. Just because the contract appears to be unchangeable does not mean it is; it can always be altered if both you and the publisher agree, either by having the document retyped or by striking out or altering the offending portion and initialling the result. But do think carefully before making a major fuss over trivial aspects; you do not want to be labelled 'difficult' at the beginning of what will, hopefully, be a long relationship.

The Publishing Process

You now write your book and deliver it on time in the agreed form (one or two manuscript copies, often a disc as well). It then goes off to a copy-editor, who will go through it for errors and inconsistencies and may suggest some textual alterations to clarify certain points. If you do not agree with these you can argue about them, particularly if they serve to change the sense of what you intend. Sometimes the manuscript will be sent back to you with these alterations, sometimes you will be sent a list, sometimes you will not find them until you get the proofs to check and correct.

Hopefully you will not have any problems and you can send the proofs back without any hassle, but first you should prepare the index (if relevant). You should have been able to prepare a list of index topics from your manuscript before you get proofs, so now all you have to do is add page numbers. There are few situations where the services of a professional indexer are required and you are, anyway, the best person to do the index as you know better than anyone what topics are important.

Then you wait for bound copies and publication day. While you wait, you will hopefully be sent a copy of the proposed cover for your comments or approval (you do not always get this courtesy) and you may be asked to write the blurb for the cover. You will be asked to provide a brief biography of yourself and your travels to go in the press release and publisher's catalogue, and you will often be asked if you will make yourself available for interviews and other promotional activities such as bookshop signing sessions. These are most likely when your book covers an area of Britain or a specific activity; both subjects are beloved of local radio stations.

While all this is going on, you should be working out

what your next book is going to be and getting the proposal off to your publisher.

For a more detailed explanation of the book publishing process and how to produce a good proposal, see my book *Teach Yourself Writing Non-fiction*, published by Hodder & Stoughton, or Michael Legat's *Non-fiction Books: A Writer's Guide*, published by Robert Hale.

3 The Importance of Specializing

Whatever sort of non-fiction writing you do, it pays to specialize. There are several reasons for this: you build up a body of knowledge about your subject, you build up knowledge about potential markets for your work and you become known as *the* person to ask when an article on that topic is wanted. The advantages of all this are particularly relevant for travel writing, a field where competition is high and you definitely need some sort of an edge when you start.

You do not need to stick rigidly to your main speciality, as long as there is a logical connection from it to your other favoured topics; people who sail tend to like other watery activities such as scuba diving and they tend to eat fish and often like to catch their own dinner; people who are interested in history will go to see the homes of historical personalities or visit battlefields. So the trick is not to delineate your special topic too closely. Think of watersports rather than scuba diving and you widen the scope to include snorkelling, wreck hunting and coral reefs; widen it a bit further and you can add wind- and board-surfing, dinghy sailing and even crewing tall ships.

One other advantage of choosing a special aspect of travel writing is that doing so automatically provides you

with topics to write up in a non-travel context, the only connection with the location being that you mention it as 'they do it differently here'. So a speciality of gardening, and a particular garden where you can either stroll round on your own, tour with the head gardener or attend a course on rose pruning would give you three approaches for three markets: for a general magazine it would be 'special holidays for garden lovers', for one gardening magazine it would also be a holiday piece and for another it would be 'a new method of pruning roses' that starts: 'While touring in Translyvania I had the opportunity to observe how Igor, the head gardener at Count Dracula's country house gets the best from the famous blood-red roses ...'

Any travel writer can do the first piece and probably the second, the only proviso being that you do need to know how enthusiasts view their world, but for the third piece you need to know enough about the activity to know what is common practice and what will be a novelty to the readers, and you need to be able to write about it in a way that demonstrates to the editor that you know your stuff. It is one thing convincing general or travel magazine editors that you are an expert in gardening, but quite another matter to convince the editor of a garden magazine that you are an experienced rose grower.

So, let us look at some of the areas you might specialize in and how you can get the best from your material.

Food and Drink

As I said in the last chapter, a high proportion of people who like to travel consider eating and drinking things they do not normally have at home to be a major part of the experience. Always popular topics with general magazines

and even general travel magazines, you can write about the food, confectionery, wines and other drinks of different places for travellers to discover and sample, plus vineyards and chocolate factories to visit and fascinating shops and local markets where holidaymakers can buy products and ingredients to take home.

On a slightly different level you can do all of this for food magazines, for which you can also investigate the origins of a particular ingredient. Take, for example, Pacific squat lobster tails, which have recently appeared in supermarket freezer cabinets to supplement the more common scampi. What are squat lobsters, why is it that you only eat their tails, and exactly where in the Pacific do they come from? Another possibility is 'In search of the true ...' stories, that take you into umpteen restaurants and local kitchens to learn how to make what each cook will assure you is the proper authentic cassoulet, sauerkraut, smorgasbord, Boston baked bean or borscht.

Then there is, 'How to make this delicious Danish pastry/Chinese duck pancake/Tamil vegetable curry at home', 'What to eat for Christmas dinner on an Australian beach', 'Japanese food is the ideal low-fat diet' or 'Quinoa – the Incas' answer to gluten intolerances'.

Going back to the travel angle, there are still guides to be written for vegetarians travelling in various countries, regular pieces on how to save money by shopping for food and wine in Calais or Ostend, witty pieces on the polite way to refuse a sheep's eyeball at an Arabian feast, round-ups on eating etiquette in the Far East, and lists of British food expressions which become offensive or obscene if translated literally into foreign languages.

Lots of possibilities there, and I have not even mentioned restaurant reviews, cookery courses, cooking on campsites or the delights of lorry drivers' cafés, all of which could well be your way in to becoming a serious food writer as

well as a travel writer. When you have done that, you might even aspire to the lucrative and prestigious *Food and Travel* magazine.

Gardening

As well as the obvious topics of special garden touring holidays or gardening courses in exotic places and 'they do it this way here' pieces, this speciality has overlaps into ecology, since people who are interested in cultivated plants are usually also interested in wild plants. Plants which are cultivated in the UK or America grow wild elsewhere and enthusiasts like to see them in their natural habitats. An example of this is alpine plants, which make their appearance in late spring as the snows recede; many of them blossom to the accompaniment of the clicking camera shutters of groups escorted by a photography tutor.

As with cooks, gardeners like to know what they can buy abroad for their gardens and a common enquiry in gardening magazines in the spring is 'Can I bring plants back from my holiday?' Organic gardeners in the UK like to read about organic gardeners elsewhere and especially to hear about the availability of 'museum' or 'heritage' seeds. If this is your interest, there are numerous articles you could write on 'What the organic movement does in Whereland' and 'These heritage plants from Whereland will thrive in your garden at home'.

There is a successful guide to B&Bs for garden lovers in the UK, but not for every other country; even if a mainstream publisher would not be interested in such a guidebook there is still scope for articles on such establishments abroad in magazines here, and equally those here for magazines published abroad. There is always scope for guidebooks of visitable gardens in Europe and elsewhere. 'The

best gardens in Europe' would be an excellent topic for American readers.

Again, there are lots of possibilities and a good chance of using this as your entrée into the much sought-after world of garden writing.

Clothing, Fashion and Other Shopping

Savile Row for men's suits, Paris for couture, Italy for shoes and Limoges for porcelain; these are obvious topics if this area interests you. They certainly interest visitors from all over the world who want to know exactly which is the best place to obtain a bespoke suit or where to buy a dinner service.

It does not have to be luxury items either. For instance it is fairly common knowledge that beautiful silk clothes and fabrics can be bought very cheaply in China and also that Chinese workers produce beautiful silk embroideries, but it also follows that silk thread itself is extremely cheap in China, a fact that will be of great interest to the embroiderers who read women's and handcraft magazines.

While there is less scope for special guidebooks on these topics, there is some for contributing chapters of information on what is available in different towns to slot into general guidebooks. In this situation, and also for articles, you will need to keep up to date on what may or may not be importable into the country where your work is published (British goods into other countries, their goods into Britain and all the permutations in between), and the rates of VAT or its overseas equivalents, and how to buy without paying it or how to reclaim it on returning home.

It is not only the shopping aspect of fashion that offers scope for the travel writer. The world is full of museums

dedicated to clothing, jewellery, hairdressing and cosmetics, all of which can be reported in guidebooks and articles. Nor does fashion restrict itself to human adornment; it is also involved in household furnishings, which themselves overlap into antiques.

Arts, Crafts, Music and Literature

All of these subjects offer tremendous scope. For instance, art subdivides into painting, sculpture and so on, and each of these into styles and mediums. There's oil, watercolour and other forms of painting; Renaissance, portraits, cubism or pointillism, plus all the other schools, even before you start to think about individual artists, famous galleries or temporary exhibitions.

There is the do-it-yourself side, with vacation courses, or competitive aspects like the World Quilting Championships. There are music festivals, regular special events like the Ring Cycle at Bayreuth, and gatherings of the fan clubs of both live and dead popular singers from Buddy Holly to Nelson Eddy, or the near-pilgrimages that devotees make to Elvis Presley's home, Gracelands.

And as mentioned earlier, every time a classic novel or even a series of novels such as Bernard Cornwell's 'Sharpe' series (set in Spain in the Napoleonic war) is adapted for screen or radio, vast numbers of people want to visit the place where it was set.

There is less scope here for articles for specialized magazines other than those which suggest holidays for enthusiasts, but plenty of scope for holiday pieces in general magazines of whatever type is most likely to cater for enthusiasts of each area of the arts.

All of these topics will also fit into various types of guidebook, from Lonely Planet to Baedeker, including

specialized guides for art lovers, music lovers or fans of classical literature.

This is one of the many areas where in-depth specialized knowledge of sites and events in Britain are highly saleable to travel magazines published abroad.

Sports

There are some sports which are best done abroad, for instance whitewater rafting. Yes, there are a couple of suitable rivers in Scotland, but most enthusiasts go to North America, Africa or Asia, where the rivers are both fast and furious. The UK is not the best place in the world for boardsurfing, either, and there certainly aren't any coral reefs to dive on. Although there are many other activity sports (hang-gliding, wind-surfing, bungee-jumping and so on) which you can do in Britain, they are all much more pleasant in warm climates. For fit youngsters, or the fit and active 'young at heart if old in body' traveller, there are treks on foot or in specially adapted trucks through remote areas of Africa, Asia, South America and Australia.

There is a vast sub-set of the holiday industry which caters for the energetic and adventurous people who indulge in these activities. Many youngsters now take a gap year between secondary school and university or university and their first job, to travel the world and see what there is to be seen, adding adrenalin-boosting adventures in the process. Some of these activities may seem suicidally dangerous to the older generation, but plenty of people want to do them and that means magazines want to print articles about them.

There are also many keen sports-people who either cannot bear to think of two weeks going by without at least one round of golf or game of tennis, others who like to 'collect' famous golf courses or tennis clubs, and a whole lot

of others who want to take up a new sport and decide to devote their holiday to learning the basics. Equally, if you have climbed Ben Nevis, it is natural to want to tackle the Matterhorn and if you are a keen fly-fisher who has only fished for trout in the UK, you may well want to fish for salmon in British Columbia.

As well as contributions to guidebooks, both general and specialized, adventure and sporting holidays are a topic particularly suited to the Internet. People of an age and income bracket to indulge in exotic sports or other sports in exotic locations are the most likely to be online.

Animal-watching and Ecotourism

Whether it is migrating song-birds in the Mediterranean, wolves, whales or eagles in Alaska, penguins in Antarctica or wildebeest in the Serengeti, people want to go and see them. For some there is a feeling that you should see them before they become extinct, for others it is just a love of wildlife. For others, like gardeners, it is the vegetation that is the attraction.

Unlike sporting holidays, which tend to be expensive, this sort of holiday is available at all price levels, from 'bring your own binoculars and a stout pair of shoes' to helicopter safaris with luxurious overnight accommodation. They are also of interest to readers of all types of magazines and guidebooks and they might overlap into some more serious writing for ecology or bird-watchers' publications.

History

Overlapping into some areas of the arts and also into religion, this subject can be split into periods of time, particu-

lar countries or world events which involved several countries, such as the Crusades. Although you can sell a fair amount of work on generalized aspects of holidays for history lovers without having any deep knowledge yourself, it is only when you either have (or know where to research) expertise that you can start writing for a more knowledgeable audience. If you do not know more than the basics about a period in history or the history of a place, you can inadvertently make dreadful mistakes which will ruin your credibility with readers and editors.

Other sub-sets of this subject are archaeology, heritage trails, special events set at a particular period (for instance many European towns have medieval festivals), anniversary events and military history. This last subject has a great many enthusiasts who will follow a military campaign round battlefields or other important sites.

One of the advantages for the travel writer based in the UK, with its easy access to Europe, is the vast numbers of people who live in the Americas, Africa and the Antipodes whose families migrated from Europe. All these people have a keen interest in their ancestral country of origin and, in addition to a general interest in that country's history, are particularly interested in genealogy and tracing their family history. The writer can take advantage of this either with general articles for general magazines or by targeting particular groups of people. A little research into the patterns of migration will show not just the obvious (for instance the high numbers of Scandinavians who settled in Minnesota) but also the fact that groups of families from, say, one English county, settled in one county of one Canadian province. This allows you to write a very specific query letter to the editor of the local paper or magazine for that province suggesting an article about that English county, especially if your suggestion is a piece about something involving those particular families.

Religion

Although this is not necessarily a subject with vast potential for general travel magazines, there are nevertheless topics which have a religious connection that would be acceptable to editors. Think of Lourdes, the old Jewish quarter and synagogues in Avignon, or the currently fashionable walks along the pilgrim routes to Santiago de Compostela. Remember that devotees of one religion can also be interested in another and suggest a trip to experience Diwali (the Hindu festival of light) in India, or Chinese New Year in Hong Kong.

There is good potential in magazines that are themselves of a religious bent. As well as articles of a devotional nature these magazines need general content. Travel articles which cover suitable events and locations come into this category and as long as you take care to use appropriate language you do not necessarily have to be a devotee yourself.

Ghosts, 'Old' Religions and Folklore

Then there is the other side of the story. Many people are interested in pre-Christian religion and want to visit pagan sites, museums of witchcraft and folklore or haunted houses. As with the more orthodox religions, these subjects do not have a great deal of scope in general publications but there are others which specialize in these topics which would welcome holiday suggestions for their readers. Note that the more 'alternative' the religious belief, the more likely the publication is to operate on a tight budget, which means low payment rates.

Methods of Travel

This category includes bicycling and canal boats but probably the most popular is steam trains. Long gone from commercial railways in most countries, there are still plenty of bands of enthusiasts running restored trains. Even without nurturing the desire to fire a locomotive, there is a romance inherent in steam trains which excites people of all ages, and many ordinary holidaymakers will go out of their way to ride on such trains.

A knowledge of steam railways, canals where boats can be hired, companies who hire horse-drawn caravans or even the humble bicycle, will allow you to produce and sell a regular stream of articles throughout the world.

Another sub-set of transport is public transport. Readers in North America and Australia are keen to travel round Europe by buses and trains, and editors are always happy to see ideas on this theme, especially if they warn of delays due to work being carried out and offer alternative routes to avoid these.

The Older Traveller

Now acknowledged to be an important part of the market for leisure travel, retired people, who are, incidentally, becoming younger as the trend for early retirement grows, are taking the opportunity to see the world. While some are every bit as adventurous as younger travellers, most are fully aware of the frailty of the middle-aged body and like their comforts.

Cruises are tremendously popular with the well-heeled, coach trips with the less well off. Other 'watch the world go by' trips such as long-distance train journeys are a growing trend and there are special tour operators who arrange trips

on the Venice-Simplon Orient Express, the Blue Train in South Africa or the Palace on Wheels in India. To a certain extent it is also people in this age group who you encounter driving round Europe, generally enjoying the scenery, photographing alpine flowers in Switzerland or gazing at Renaissance frescoes in Umbria.

Some older travellers, those over about seventy, though not actually disabled may be a bit frail and they like to be assured that trips you suggest will not aggravate painful joints or upset delicate digestions. They like hotels with lifts, and porters to carry their luggage, and most of them prefer an early night to whooping it up in night-clubs. Although you do not have to be old and frail yourself to write for this audience, it helps if you are old enough to appreciate their concerns. This is one of the joys of travel writing – it is a career you can take up when you are old enough to retire yourself!

One travel writer reported a flight over the Rockies, when he found that most of his fellow passengers were elderly. He said that after tuning in to some of the conversations around him, he was convinced that if he had stood up and asked 'Who knows the name of the geological formation below us?' practically everyone on the plane would have put up their hand. They would probably have been equally well informed about the vegetation, the wildlife and the local agriculture and industries and you need to keep this in mind when writing about places to visit. It is also a good idea to mention incidents which would have been reported in the national press over the last twenty or thirty years, as your readers will remember having seen them at the time and this gives them a sense of 'belonging' to the place.

It is for this audience that most travel newsletters are produced, so do not neglect these when seeking markets for your work.

Travellers with Children

Two things typify these travellers: they normally only travel in school holidays and they go to places where there is plenty to keep the children occupied. Many prefer the economy of camping holidays in the UK or Europe. The dedicated travel magazines rarely mention children, but general magazines do and special parenting magazines like travel pieces for their readers.

As well as guidebooks and accommodation guides aimed at parents, there are certain types of article that can be repeated each year: 'How to keep your toddler amused on aeroplanes', 'What to do if measles breaks out when you're away', 'Games to play on long car journeys' and 'Is it safe to go in the water?'

'Days out in the UK' is always a popular topic and since the opening of the Channel Tunnel, it is possible to visit Disneyworld Paris for a weekend, although with the way transatlantic fares have dropped, it is almost cheaper to take the family to see Mickey in Florida (there's an idea for an article). There are other attractions in Europe, including an Asterix theme park north of Paris, a Legoland in Denmark and Christmas trips to Finland for a sleigh ride to visit Santa.

For the writer with experience of travelling with children there is plenty of material and no shortage of publications to place it.

Business Travel

This is really 'Tips for business travellers', as business travellers are not in the position of needing help on deciding where to go. However, they do like advice on getting their flight or hotel room upgraded, what to pack in their

carry-on luggage as a precaution against lost luggage, avoiding or reducing jet-lag or even which airline to choose. One of the most useful tips in Mark McCormack's book *Hit the Ground Running* was that the national carrier always gets the best landing slots in its own country.

They do like shopping tips and information on entertainments and restaurants, and to a certain extent on hotels, since most executives can choose where to stay. Advice on where to entertain your foreign business contacts and how to behave when they entertain you is always useful, including the most acceptable gifts to take when entertained in a business contact's home.

Markets for these topics are business magazines rather than general or travel magazines or newspapers, plus the magazines issued by big hotel groups and major credit-card companies, airline in-flight magazines (especially those for Club Class passengers) and car-hire companies. Also, if your speciality is a particular country and you can get the national tourist office to give you details of what major trade exhibitions and conferences will be held there in the coming year, you can target the relevant trade magazines with a piece that goes: 'Going to Timbuktu for the big conference this year? While you're there, don't miss ...'

Specializing in One Country

As well as the major advantage of being known to editors as the person they can turn to if they decide they need a travel piece on Whereland, you will also find that keeping the Whereland Tourist Office supplied with a steady stream of pieces extolling the virtues of their country means you get first choice of press trips and high-level co-operation. They may even pass your name to editors who ask for information, and when little-known countries like

Whereland hit the headlines for any reason, your name will be the one passed by the travel editor to the news editor and you will find your expertise is in demand for general background information.

When choosing a country as your speciality area for any reason other than personal preference, it is a matter of balancing the value of exclusivity as a big fish in a small pond with the possibly limited opportunities for publication. There is a limit to the number of pieces you can publish on an unknown country over any given period. Perhaps the answer is to add a larger and better known neighbour to your area of expertise, thus getting the best of both worlds. But of course, it is almost always personal preference that leads to one-country specialization.

The more you go and the more you discover, the more you will find there is to write about and the more interesting you will be able to make your writing. Instead of being restricted to reports of what you saw and what your readers can see, you can extend your repertoire to include explanations of why particular aspects of life in that place are important, and you can comment on the traits of the local character that may be relevant to visitors.

4 Researching Topics

The ability to write well comes only from knowing your subject. Without adequate research, what you produce has the quality (or rather the lack of quality) which editors call 'thin'. It is a common cause of rejection.

Without some background, all you can do is report on what you have seen, heard or tasted, so everything seems one-dimensional. It is like being shown a set of holiday snaps by someone who has just come back from the Serengeti, only to find that every photograph is of them with friends round a series of swimming pools, dinner tables or card tables. Did they not see any African villages, exotic plants, big game? No elephants? No giraffes? Not even a snake?

You wonder why they bothered to go if they did not seem to have had the curiosity to see all the wonderful things that were there. It is that curiosity which is essential to a travel writer, the quality that is the main reason for travelling. And to satisfy that curiosity, you have to do the research that allows you to understand what you have experienced, to flesh out the bare bones.

There are several phases of research. The first is what you do when you are planning a trip, to give you an overview of the place that allows you to decide what you want to do when you get there. The second is what you do when you

are at your destination. The third is what you do when you get back and are actually writing your piece. The fourth – well, it is not really the fourth, because it is what you do all the time, as you search for interesting places and events or continue to build your knowledge about your speciality.

Sources of Information

Until you can build up a library of your own travel information, the obvious place to start is your local public library. Someone once said that a writer who lives near a good library is lucky, and that a writer who does not live near a good library should move. These days, with funding cutbacks, you may find your local branch lacks what you need and you have to go to central reference. It is the less popular books that will be in the reference section, such things as detailed histories of foreign countries, information on permissible imports and international VAT rates, detailed geographies and such general things as *Encyclopaedia Britannica* (although this is now available on CD-ROM). Most branches will have a reasonable selection of autobiographical travel writing and guidebooks of all sorts, which will give you the basic information on each country with an overview of its history, culture and politics as well as specific details about its cities and bigger towns. These guidebooks will not necessarily be the latest, but that isn't crucial at this stage.

If you want more and it is not on the shelves or at a central reference, it is time to use the reservation system. It is worth taking the trouble to make friends with the librarians who process reservations and to let them know when you need something quickly. If in doubt as to exactly which books you need, order them all. It is better to have too much information than not enough. The whole essence of

research is that you follow a trail from one item to another; often one book will mention something only in passing and you have to check the bibliography and order another book to get the detail.

The next source is the relevant tourist office. The degree of helpfulness varies from one country to another and even from one branch to another. Taking one specific country (which had better remain anonymous) as an example, their London office is helpful though rather slow, but American writers report that while their Los Angeles and Chicago offices are quick and helpful, their New York office is run by someone who considers that their duties do not include assisting travel writers.

Each country's tourist office operates differently. Some insist that you deal with a press officer, others do not; some have open telephone lines so you get through to a human being who will listen to your query and connect you to the right person, others have a single telephone number listed in the directories which turns out to be a premium-rate line, or one which only connects you to a recorded message. It is not easy to find a number that will get you through to the press office in these situations, unless you can find another travel writer who knows it and is willing to divulge it. Once you have managed to get through to what seems like the right person you may find it is not after all, since responsibilities are split and someone else in another office deals with the area you want to know about. Belgium is like this; it has two separate offices in different buildings in London, one dealing with Brussels and the Ardennes, the other dealing with the rest of Belgium.

If you find it difficult to get the right person on the phone, it is best to write and ask for what you want. Tell them a bit about the article you have in mind but do be careful about mentioning that you intend to place it in an overseas publication; some will respond by saying that you

have to ask the tourist office in that publication's country of origin. Others, regardless of who you are writing for, will refer you to the regional tourist office or the tourist office in a specific town.

What you get back will vary tremendously, too, from a large envelope crammed with maps, brochures, guides and a CD-ROM of photographs to a polite letter giving you a website address and telling you that everything you need to know can be found there. (Some even tell you this on the telephone; this happened to me on one occasion and when I asked what they said to people who did not have Internet access on their computer, the answer was an airy, 'You can go to a cyber café and view it there.') Some will pass your address to various hotels and tour operators and you will get more information from all of them. The brochures themselves may be bang up to date in perfect English, out of date by several years, in fractured English or not in English at all.

As you will see from all this, part of the learning curve is finding out how different tourist offices operate and how to get the best from each one.

Another source of brochure and transport information is travel agents. What they will have will mainly be package tours, but they should have something in the way of schedules for the most obvious national airlines and information on specific hotels. If you travel a lot and pay for your own fares and accommodation, try to use one travel agent for all your bookings; once they get to know you as a loyal customer they should be prepared to get some more detailed information for you.

When you have publication credits and cuttings to show, you will be able to get into the World Travel Market and the World Travel Trade Fair. These are two big events, held respectively in London (Earls Court) in November and Birmingham (NEC) in March each year. You can either

apply for a free press pass in advance (from 01580 201178) or turn up on the day and tell the turnstile staff you are a journalist. They will send you to the press reception area where producing clippings of half a dozen of your published articles will get you the pass and a large bag of information including the 500-page catalogue of all the exhibitors.

Arranged in geographical blocks (Europe and Mediterranean countries in one area, America in another and so on) each country's stands will include staff from their London tourist office, some regional or town tourist offices, tour operators, hotel groups and time-share companies. In a side hall, in what they call the global village, are all the international companies such as car hire, airlines, big hotel chains etc. This is a good way to get hold of in-flight and other give-away magazines.

Although you can attend on any or all of the four days, the first two are designated press days and that is when you can be sure of finding the press officers on the stands. They may be there on the last two days as well, but they may not, in which case make sure you get their name and direct telephone number. It is a good idea to carry a selection of your cuttings in an easy-reference folder so you can show stand staff what you have done and thus what you will be able to do for them in the future. You will also need a good supply of business cards; you can easily get through fifty in a day. Most stands have a pad of 'information requested' sheets on which to note your interests so you can be added to their database. You will be given vast amounts of brochures and more will be sent in the following weeks. If you do not want to carry a great weight round all day, ask them to put a selection in the post for you.

If you do not know how the travel industry works, these trade shows will be an eye-opener. While a lot of journalists and freelance writers do attend, the shows are intended for

countries and various companies to sell their wares (accommodation, transport, tours, etc.) to travel agents. This is where they put together the packages that the individual holidaymaker buys, and where the emergent holiday destinations in what used to be restricted parts of the world as well as everywhere else strut their stuff; it buzzes with energy and despite the weight of brochures weighing you down you will wish you had brought your passport so you could dash off to the nearest airport.

There are also holiday shows aimed at the general public but they are not a patch on the trade shows. They may not be as generous with their press passes and you could find you have to pay to get in.

Many countries and companies, rather than having their own press officer, use PR companies to do this work for them. It is easy enough to find out who these are by asking, then when you contact the PR company, take the opportunity to ask them who else they represent. However you get hold of names and other contact details for these PR companies or other press officers, guard them well; they will be invaluable to you.

Research on the Internet

Success in Internet researching comes from being very specific in the wording of your search requests. If you ask for something as general as 'holidays in America', your search engine will offer you several hundred thousand choices. You have to be as specific as 'holidays in Orlando, Florida in August, NOT Disney'. If you know the name of a specific organization or town, typing *www.towname.co.uk* (or any of the other standard suffixes such as *.com* or *.org*) often works. You will need to know the suffixes used by different countries, for instance France, is *.fr* and Canada is *.ca*.

It is sensible to start your own list of potentially useful website addresses culled from newspapers, magazines and guidebooks, as well as travel articles published on the Internet itself. Often the best source of website addresses is the libraries of frequently asked questions (FAQs) on travel forums or the members of travel forums. Just address your message to 'All', say what you need to know and ask if anyone can suggest a useful website or offer other information. Do be wary of using such information without checking it, though, as the quality of information garnered this way is notoriously variable.

Your own service provider will have some targeted research indexes, as will most of the search engines (my favourite search engine is *www.profusion.com*). Most offer a series of menus arranged by subject which link to specific websites and also offer you the option to specify which country you are interested in. You can also link into news groups by putting travel.news.groups into your search engine's request box.

Another useful resource is the online versions of guidebooks. These will be more up to date than the printed versions but they are still only as accurate as the last time they were updated and you should always check opening dates and times, transport times and prices of everything from primary sources. You should also take care that your use of the information does not constitute an infringement of copyright.

However, do not forget that what is on the Internet is neither foolproof nor complete; it only contains information which someone has troubled to scan into it, and someone else's idea of 'comprehensive' somehow never matches one's own. The moral is that while the Internet can be a useful research tool, it is never the total answer and you usually end up having to consult books and other paper sources.

Building Your Own Research Library

Every travel writer needs a good atlas, and there is none better than the *Times Atlas*. It is not cheap, but for most purposes an old copy will do (although the latest edition has wonderful satellite photographs), so look for one in second-hand bookshops. Whichever you choose, make sure that what you get has large-scale geographical maps as well as political maps and some indication of climate, crops and population distribution. There are some good maps on CD-ROM which allow you to zoom in on certain areas; these are getting better all the time, and no doubt you will soon be able to download them from the Internet.

Then you will need some information on your area of speciality. If it is a country, start with some more maps, going as large-scale as you can. Try to get the local equivalent of the British Ordnance Survey if such a thing exists (for instance for France it's the Michelin Routier, for America it's Rand McNally), then a selection of general guidebooks. You need a selection because the different series emphasize different aspects; one which is aimed at impoverished backpackers will not contain enough information on good restaurants, art galleries and museums. Then you will need a selection of accommodation guides, and whatever strikes you as useful in the way of specialized guidebooks. As with the atlas, these do not need to be completely up to date and can be bought second-hand. Libraries often have periodic sales of old books and this is a useful way to acquire guidebooks and others. The point about old guidebooks is that while things such as times and opening dates can change from year to year, the fundamentals do not. Museums, churches and other monuments stay the same, economic activities do not change very quickly and market day in most towns has been a fixed point for centuries (to the extent that the word for Friday in many

languages comes from a root which means 'market' or 'selling' day).

General geography or economic geography books on your favourite countries are essential, as are history books. It is also useful, unless you never intend to go outside the big cities, to add some field guides to wild flowers, trees, birds, butterflies and other wildlife and, if you can find it, a guide to the crops you may see growing in the fields. (Collins publish an excellent guide to the crops of Europe.) All of these, quite apart from the fact that they help build up your knowledge of a place, will add authenticity to your writing by letting you name things properly instead of having to say 'a field full of some sort of corn'. Transport maps and timetables are a good addition. Thomas Cook publishes continental and overseas timetables (available from major railway stations) for local ferry and rail services in Europe, North Africa and the Near East.

Once you have an interest in a place, keep newspaper cuttings about all aspects of it, everything from literary awards to news on the economy or industrial action, sporting successes or anniversary events, as well as travel pieces. Ask your friends to pass on the travel sections of their newspapers and add these to your collection, but if you cut out articles, make sure you keep a note of their origin and date. It is well worth subscribing to *The Economist*, which publishes excellent world-wide information on politics, history, art and science as well as finance.

If your speciality is something other than a location you will want to collect information on that as well as you may want to organize some sort of cross-reference system on it. For instance, if your subject is painting, it would be useful to know where the little-known gems as well as the most obvious works of a particular artist are to be found, so that you can slot these into pieces suggesting tours in certain areas. For instance, it is fairly common knowledge that

Goya's Majas (dressed and naked) are in the Prado Museum in Madrid, but less well known that there are more Goyas in ten other collections and churches in and around that city.

Learning the Language

If you are sure you are never going to go outside English-speaking countries you need not worry about languages. Anywhere else and you will need to learn some and equip yourself with a good dictionary. For the average tourist it does not matter, as in the places they are likely to go there will be plenty of people with at least a smattering of English. As a writer, quite apart from the fact that many of the brochures you collect will not be in English, you need to be able to get below the surface and for that you have to talk to all sorts of local people, many of whom will not have a word of English.

As to which languages will be useful, that depends on where you will be going. For northern Europe, French and German are the obvious languages, for southern Europe it should be French, Italian and Spanish (in fact, if you are reasonably fluent in any of these, it is easy to get by in the others, including Portuguese). For some parts of the USA, Central and South America, Spanish should be your choice. These few European languages will work well enough in many other parts of the world too, a legacy of European colonialism. Elsewhere, you will have to enquire at the tourist office sufficiently far in advance to allow you to acquire the basic pronunciation and some phrase books.

The point is that you should make the attempt. Most people will appreciate that you are trying and will be much more patient with you than if you do not try at all. Carry a

dictionary and if you do not know the word, find the English one and show them the entry, and let them do the same for you, a technique that has tremendous scope for mutual goodwill. You can buy hand-held translators or Berlitz chips for palmtop computers; these are slow, as you have to type in the word you need, and they tend to have rather restricted vocabularies, but they are a step in the right direction. If all else fails, try drawing the subject of your query in your notebook.

If you have the basics of how the grammar works and a reasonable vocabulary, you can mug up on special topics when you have interviews arranged. As long as you have a good understanding of something in your own language it is easy enough to follow what you are being told about it in another; for instance my French is adequate but not marvellous, but my interests include cooking and gardening, so I had no problems understanding the work of a French experimental fruit-breeding station, or their suggestions for using the apricots and peaches they were growing.

These basics and a comprehensive dictionary make it possible to get the gist, even if not all the nuances, of brochures and even magazine articles. Another possibility is computer translation software, especially the 'Language Assistant' series. You type or scan in what you want translated and it then does so, with a spoken version if you wish. When the program comes across a word it does not know, it asks you for its meaning and what sort of word it is; for verbs, it asks you how they conjugate. You look it up in your dictionary and type in the details and the program stores it away for the next time.

If all else fails, you might think of using a translation agency, or the less expensive option of finding an impoverished language teacher at your local adult education establishment.

Researching on the Spot

There are some pieces of travel writing which you can do without taking a trip, such as round-up pieces of what cookery courses are available, or which paintings are in which galleries, but for most pieces you need to go and experience the place for yourself. Your reaction to any place or situation is going to be coloured by the person you are and the things you are interested in. (The classic example of this is to consider a large piece of land; a dairy farmer looks at it and works out how many cows it will support, a builder sees it in terms of house plots, a footballer in terms of pitches, and a pilot licks a finger and holds it up to see where the prevailing wind comes from and thus which way the runway should go.) Travel writers often mention their first press trip and their concern that everyone would write about the same things, then say that when they checked afterwards, although everyone had been taken to exactly the same places, each piece was different.

Nevertheless, there are a few things that every writer should do when they arrive in a new place. The first is to orient yourself, working out where north is and looking at a map to see where this place is in relation to other known points such as the sea, a mountain range, a forest etc. If you are in a town, have a good look at a street map to see where all the interesting places are, so that you, and your readers, can get from station to hotel to museum to cathedral. Then find out where the tourist office is and pay it a visit, introducing yourself and asking what they suggest you see and do.

If the place is big enough to have organized sightseeing tours by bus or boat, go on one for further orientation and to get an idea of what will be worth a proper visit. Then it is best to explore on foot, pausing to make notes as you go; an intriguing little alley, the way people are dressed,

whether they stop to chat on the street or sit outside cafés with a coffee and a glass of something, what is in the shop windows, how neat (or otherwise) the houses look, the different smells coming from houses, restaurants and shops as you pass, all the local colour. Do not tell yourself you will remember it all; you won't, or at least you will end up confused about what was in which place.

Do not forget to look up as you go. People hang bedclothes over the windowsills to air, or hang their washing to dry or their canary cage out for some sun. Cats and dogs take the sun on balconies or people lean over them to gossip with their neighbours. In the older parts of town there will be interesting decorations on the buildings (or the marks of machine-gun fire), or interesting roof tiles or chimney pots.

As you walk about, note which parts of town are which, where the affluent people live and the professionals have their offices, where the poorer people live and whether any areas look too dangerous for strangers to venture into. Where do the teenagers hang out and perform their mating promenades, are there beggars or drunks on the street and are the police armed?

As well as sitting outside a café with a drink (or inside by the window if it is cold or wet) nothing beats a big railway or bus station to watch everyone go about their lives. In Europe you will see plenty of people with dogs, in poorer parts of the world it is more likely to be a goat or even a pig. In the street markets there will be livestock, too, baby ducks and rabbits, and fat adult versions (do not ask, if you are sentimental about animals), and the smells will vary as you move from the live animals to the sausage stalls and on to the fruit and flowers.

If you can speak the language, take any opportunity to strike up a conversation with the locals and ask them what you should go to see. They will tell you about places that

none of the guidebooks or brochures mention. But be careful when asking if it will be open or how far it is. There are many places, especially in Africa, where local good manners do not allow people to give you bad news. You may be assured that it is open all day every day and only twenty minutes' easy walk away, only to find out three hours, two steep hills and an unbridged river later, that it has been closed and abandoned for years.

Do make a note of what people say in your notebook, even if it means you have to sneak out to the toilet to do it. These remarks and comments are invaluable and will often give you the opening to your article.

If you see people doing something interesting as they work, wait for a chance to ask them what they are doing. Those pieces of blue-ended stick the man is pushing into the ground at carefully measured intervals could be anything from preparations for a complex game to measurements for a new housing estate – until you ask and he tells you he is planting grape cuttings and the blue stuff is a new type of hormone rooting paint. 'Come back in five years,' he may say, 'and you can taste the wine.'

Apropos of fields, it is useful to teach yourself to measure distances and sizes by eye. Find out the dimensions of something you are familiar with – a football pitch, your bedroom at home, your dining table – then calculate how many of those would fit into the field or sports stadium or restaurant. Another useful skill is calculating the number of people in a gathering, which allows you to report the numbers at a bullfight, a sporting event or a shrine. Just count fifty people, work out how much space they occupy and do the arithmetic.

As far as measuring smaller things is concerned, use your own body as the base measurement. Everyone knows how tall they are and can use that to work out the height of doorways and big animals, but it is also useful to know the

width of your shoulders (for the width of doorways and passages) the length of your legs and from ground to waist (the height of chairs, window sills or plants), and the length of your fingers and the span of your hand (the size of loaves of bread, exotic flowers, cheeses etc.).

All of these measurements and everything else should go into your notebook as soon as convenient. When you stop for lunch and at the end of the day, add details of the weather and your impressions and reflections. Keeping a travel diary like this will prove invaluable when you get home and start to write, and as well as providing detailed information on what you set out to see, it will help you write many other pieces. Some writers like to go through their notebooks and use coloured highlighters to mark the names of towns and other places, plus things that relate to their speciality. That way you will easily be able to locate the gallery where you saw an unusual sculpture attributed to Michelangelo, and if an editor asks you if you know enough about a certain town to write about it, you can quickly locate your notes on it.

Beginner writers often ask how you know when you have done enough research. The answer is that you do not know until the article is written and accepted. The whole purpose of research is to allow you to do the job of writing and you do not need to know every single fact about a place to write an interesting and informative piece about it. Obviously if you have a speciality you should continue to investigate interesting things, but you are still only doing this to enable you to write more articles or a book. That said, research is one of those iceberg things, where what shows on the surface should be dwarfed by what is hidden below.

So anything that adds to your general picture of something you expect to write about many times is useful, as long as you do not fall into the trap of using research as an excuse for not writing.

In fact, you do not need to do any more research than what will allow you to make a couple of authoritative statements and whet an editor's interest in your query letter. You can state that a town has a cathedral, a synagogue and three museums without knowing the precise locations and opening times of any of them. If the editor is not interested, you may never need to know. On the other hand, do make sure that the expert you have in mind to answer your questions is not about to take maternity leave or a prolonged sabbatical.

Organizing Your Research Material

Unlike many other genres of writing, where you can put all your material onto file cards or a computer database, what you accumulate as a travel writer is a great deal of bulky stuff in various shapes and sizes. Maps, brochures, booklets, CD-ROMs and newspaper and magazine cuttings, there is no way to store it neatly. What you need is to be able to find specific things quickly, to know where they came from and how old they are. All of this can be achieved by putting batches of material in large envelopes and writing a note of the contents on the outside. You might have one for Madrid and put your Goya information in it with everything else, or you might have another for Goya and make a note to that effect on the Madrid envelope.

All you have to worry about then is how to organize the envelopes. The options are some sort of filing cabinet (upright multi-drawered cabinets can be bought very cheaply second-hand), a set of stacking plastic boxes or a simple shelf with the envelopes stacked in sideways. In the latter case, staple labels to them or use a slightly larger piece of cardboard at intervals to divide up sections.

The next question is how long you should keep any piece

of information. If it relates to something you do not expect to write about again, you only need to keep it long enough to answer any queries that may come after your article has been published. With things you do expect to write about again, you can throw away anything as soon as it has been replaced by a new version. This applies particularly to tour operators' brochures and price lists, but do be sure that what you are dumping is fully replaced by the new material. Do not, for instance, throw away the winter brochure when you get the summer one; you may need that winter information before the replacement winter brochure comes.

With everything else, you just have to go through it regularly (say, at six- or twelve-monthly intervals) and make your own decision on its ongoing usefulness. It is, anyway, a good idea to check through everything at intervals; you will be surprised what new article ideas will come when you have not looked at material for a while.

Final Checks

The last thing you should do, indeed *must* do before you send your work off to the editor, is recheck all your facts. Are all the names spelled correctly with the proper accents in the right place? Are all the places you recommended still open, or have they decided to close for repairs? Are the prices and phone numbers still correct? Has the manager changed, or the painting you praised been lent to another collection for a year? If you recommend anything, either specifically or by saying how much you enjoyed it when you visited, your readers are entitled to be able to try it for themselves and to replicate your experience. For this reason, you must resist the urge to exaggerate or 'massage' the facts. And you should check all facts by going back to the primary source, not by cribbing from a guidebook or

someone else's article; after all, how can you be sure how, or when, they got those facts?

The very least you can do is make sure your facts are accurate when you send them to the editor. If there is a long pause between acceptance and publication, and you find out that something has changed, write and tell the editor. You may get a phone call to say they are about to go to press and do you know of any changes, but the trend now is for magazines to employ fact-checkers to do this job at the last minute – another reason why you should be sure it was right when it left your hands.

5 Getting and Developing Ideas

The one thing you can be certain will never happen when you are starting out as a travel writer (and not that often when you are established, either) is a telephone call from an editor with an idea for you to write up or a free trip for you to take. For most writers, most of the time, the business of finding things to write about is part of the job.

It is not just things in general to write about, but subjects which will appeal to a specific publication because they will interest that publication's target readers and because the writer tackles the writing in a way that fits the editor's perception of how those readers like to have information presented.

There are numerous types of travel article and part of your market research is to note the types each publication uses. This will enable you to crystallize your general ideas into specific ideas with a target market in mind. This does not mean that any given idea can only be tackled one way; one set of information can often be rewritten into several types of article without having to do any more research.

Different Categories of Travel Article

Destination pieces are the most common type of travel arti-

cle. They deal with a specific place: a town, city, area or tourist attraction. For most publications other than narrow-circulation trade magazines, when you might feature an unknown town that has a trade connection, the destination should be on a main tourist route and easy to reach.

Journey pieces either deal with the mechanics and delights of a travelling holiday, such as a horse-drawn caravan, canal boat or long-distance train, where you sleep on the transport, or a journey with stops at various points. These points might be merely incidental to the route, mentioned as mileposts along the way and to illustrate how the landscape and people change as the journey progresses, or they might be linked by the purpose of the journey, such as shrines along a pilgrim route. Nor does a pilgrimage have to be one of religious devotion: many people like to follow the migration routes of birds, a medieval trade route or a journey from one of their favourite books.

Activity pieces will either concentrate on a single activity, such as skiing, or several linked activities such as skiing, snow-boarding, tobogganing and ice-skating, all of which can be done from a particular resort. This is much like a destination piece but with the emphasis on the activity rather than the place. It will cover the actual locations where each activity can be performed (ski-runs, ice-rinks etc.), and a selection of hotels, and since these pieces are mostly aimed at younger readers, should not omit the night-life.

Much like activity pieces are **speciality pieces**, although they will often cover a wider area than a single destination. Typical of these would be cookery courses in Burgundy, tours of American Civil War battlefields or 'real ale' tours of the West Country.

Anniversary pieces can encompass several of the above but centre on the fact that an anniversary of some sort is

being celebrated. It might be that of a political event such as the French Revolution, the founding of a town in one of the countries settled by immigrants or the birth or death of a historical personality such as a composer or painter. Whatever the reason, it is an excuse to attract visitors to the place, and for the writer it has the advantage that you can recycle material you have used before on the generalities of the place as background to the main event.

All of the above can be done either as a continuous article or as round-up pieces consisting of a series of short paragraphs only connected by the title and a brief introductory paragraph.

Special-interest pieces may be on a specific trade in a particular place, which you write for the relevant trade magazine, or might feature shopping (a particular shoe factory in Italy) or food items (apricot farming in southwest France or cheese making in Holland).

Side-trips from a popular destination cater either for individual members of a family or group who want to do something different from the others or the whole group when the main attraction (especially if this is a beach) palls after a few days. So you suggest some things to do within easy reach of wherever it is, say the Costa Brava, which can be achieved between breakfast and dinner time. It might be hiring a car to go and admire the scenery, a particularly good country restaurant at the end of a bus-ride or just an interesting village that is fun to visit but which has nowhere to stay.

Reviews will feature the hotels, restaurants, art galleries and museums of a particular area. Reviews of a single establishment can be quite short and are often used as fillers.

Lists and tips are mostly aimed at novice travellers or those new to a certain place or activity. Topics might include:

- five important things you need to know about skiing
- ten good books for the beach
- twelve places to have a suit made in twenty-four hours in Bangkok
- twenty useful phrases you won't find in a phrase book

There are a few other types of travel article but most are just variations on these themes. What you have to do is apply those categories to your own experiences and other idea sources and see what specific publishable ideas they produce.

Ideas from Your Own Travel Experiences

Cast your mind back, or go through the notes from your last trip. You will probably have come back with one or more aspects of it burning in your mind as things you want to write about.

The first thing you have to ask yourself is whether you enjoyed them because they were inherently enjoyable or whether it was because they were new to you. If the latter, then you have to consider whether they would have equal novelty value to your readers. That is not meant to be patronizing; you just have to remember that it is a possibility. This is one of the situations where an experienced writer, whilst on the spot, asks, 'Do you get a lot of British/Americans/whoever here?' If the answer is 'No' or 'Only in August', you may have made a discovery, but if the answer is 'Yes, lots' you may be up against the 'been there, done that' syndrome.

Next, consider who was there, to find your reader focus. Were they predominantly youngsters, parents with young children, middle aged, older? What else were they doing while they were there? Who they were and what they were

doing allows you to report each aspect from that group's viewpoint; for instance, the hotel was all right and the entertainments were better than all right but what was really great was the way everyone fussed round the children and did not worry when they got a bit over-excited.

The point is that you are going to have to tell the story in somewhere between 800 and 1,200 words, rarely any more. Short pieces do not allow you to cover everything so you have to make a decision on the likeliest market for it. You can always do another piece with a different focus later.

See if you can encapsulate the whole thing in a single sentence:

- Wheretown is great for kids, and mum and dad like it too.
- Wheretown's excellent hotels and fine restaurants offer a real gourmet experience.
- It has sun, sea, handsome boys and fabulous discos.
- The beach is sandy, the beer's cool and the girls are pretty.

That will give you the tone, and the main topics, for the piece. Youngsters do not care about fine dining, young parents might but only if there are trustworthy babysitters, and the older visitor might like a gentle stroll on the beach, but certainly does not care about discos.

What else did you do or see that could make another type of article? While your partner was skiing, did you try ice-skating? You will not be the only person who does not want to whizz downhill and if the ice-rink was inviting, with skates for hire and friendly instructors to get you started, you have got a side-trip piece. What food was served at the *après-ski* parties? That could make a cooking piece. How about the restaurants? That is a review piece: 'Three places to eat in Whereville, forgotten centre of the

Val de Ski'. Did anyone tell you, 'I never go skiing without my wotsit widget'? (Where did they get it? What did it cost?). If so, you have the beginning of a list, or all of it if enough people favoured different widgets.

Anniversary pieces are different. You cannot do them after the event, since the whole idea is that readers should go themselves, but what you can do is keep your ears open, or ask at the tourist office if there are any special events coming up. If it is imminent and there are still vacancies in the hotels, you have a travel news piece. If it is further off, you have time to go through the query letter routine when you get home, but you should make sure you find out exactly what is going on and maybe talk to the local expert if it is the anniversary of a historic event.

For this reason you should pay attention to dates when important events took place or when the local important people such as composers or artists were born or died. Asking about such possibilities well in advance will give you the edge on other writers who do not find out until the main announcements, and with any luck it will be you who gets the commission to write about them.

Ideas from Other Sources

These sources can be anything from guidebooks and brochures to books on your speciality, articles in papers and magazines or items on television or radio. What usually sparks off the best ideas is a passing mention of something you feel you would like to know more about. If you want to know more, it is reasonable to assume that other people will too, but not in the same publication (or not for many months). It is worth going through your clippings file every so often to see what various magazines have done in the past. Although obviously your piece will have to be more

than an update, if the time lapse is long enough they may well be ready for that topic again.

Another reason for keeping a file of other people's travel writing is that these pieces will trigger ideas on ways you can treat your own material. If one piece centres on the specialist bakers of a small town in Provence, you may remember that you have seen special cake shops in Mexico City. Another may feature the gauchos of the South American pampas and remind you that you have some material on the horsemen of the Camargue. The more you read other travel writers, the more you learn about ways you can tackle what you have seen and the easier it will be to separate out the component parts of your own experiences.

Do not forget travel trade shows. One advantage of going round the stands is that as well as seeing what is on offer (I would never have thought of playing golf on a glacier until I saw it on the Greenland stand), you can ask the staff if they are noticing any developing trends. Are they getting more visitors from a particular country or of a particular age? Are people showing an interest in something different? This will allow you to go back through your old notes with a new perception and you can also phone round your other tourist-office contacts to ask if they have noticed the same trend. Try to get some statistics that will help you write your query letters to editors and get those letters off before someone else realizes a trend is building and beats you to it.

Some guidebooks invite readers to contribute information on their own favourite spot or activity, and these can be a good indicator of a growing interest you can exploit. This is a good way to cultivate an awareness of what interests other people. It is easy to get so wrapped up in your own special interests that you ignore everything else. Remember that the secret of success (i.e. the ability to earn good money

from your writing) is to get as many articles as possible from one trip and the subsequent research.

Often it is the research for one piece that gives you the idea for another; and in researching that one you come across another and so on in an unending cycle. People who do not write are puzzled where writers get all their ideas from, those who do know it is a matter of observing the world in a certain way, turning a casual 'That's interesting' and 'I wonder ...' into 'Here's something other people would like to know about.'

Writing About Britain for Overseas Publications

It is sometimes difficult to see your own country as a tourist venue, but you only have to walk through the streets of any of the big cities in summer to realize that tourists do come here in great numbers. The trick in exploiting this by writing for overseas publications is to remember that most tourists come to Britain because it has things they do not have at home. We go abroad to ski, sunbathe, see different scenery and drink the local wine. People come here because we have old houses and ancient history, one of the few remaining monarchies with all the attached pomp and ceremony, whisky distilleries and old pubs and world-famous gardens. One of the things which strikes people from hot countries is how green Britain is all year round, and the Japanese are intrigued by our culture because it is so different from their own.

There are numerous guides to the gardens of Britain and both English Heritage and the National Trust publish programmes of special events at their properties. The various tourist boards here, just as abroad, will be more than happy to send you material on request and a quick phone call will get you information on affiliated groups in your

target country. The 'Hidden Places' series of guidebooks to the counties of Britain will guide you towards some unexpected gems. All of this should be available in your local library and a few hours' browsing should give you plenty to start with.

It is sensible to specialize in the area round your home, partly because it is easier to visit various locations if you do not have to spend several hours getting to them, and partly because your local library will have local information on the shelves for you to borrow. There should be detailed histories of your own and neighbouring towns, plus biographies of famous local people and guides to famous local buildings. The same information on distant locations will only be available through the reservation system, which presupposes that you know the books exist. Central libraries will have other documents besides bound books (maps, collections of letters and old legal documents), all of which will allow you to intrigue your readers with information which is not readily available elsewhere. However, you will have to view these on the spot and may have to make an appointment to do so.

Developing an Idea into an Article or Book

Taking an idea and turning it into a finished piece of travel writing is, you will be pleased to know, something that gets easier with experience. Understanding that the fewer words you have to play with the tighter your focus has to be, is a big part of the battle. To a large extent, the rest of it is a matter of structure.

The one thing that rarely works, and which beginners are sometimes prone to do, is to recount the whole of their trip in detailed sequence: 'We did this, then we did this, then we did this'. Desperately boring stuff and most of it irrelevant

to what the article should be about: the encapsulation of the experience. So the trick is to decide what is relevant to that and discard the rest.

This is another situation where a coloured highlighter helps. Having decided that you are going to aim an article at parents with young children, you can go through your notes and other information, marking everything parents will want to know and ignoring the rest until you do the same exercise with a different colour for a different article.

Then all you have to do is sort it into a logical order, decide how to start and finish it and write it. Logical order means all the similar sub-topics should go together. The basic problem with the 'We went, then we went, then we went' structure is that you went from a hotel to beach to café to shops to hotel to restaurant to night-club, repeating that day after day, so the reader who only wants to know about restaurants has to wade through the rest to find them. They do not want to read full details of all of them, either, only the best two or three. If you feel you need to mention more, you can do it in a box. Give the addresses and phone numbers of the best, then add, 'We also ate at ...', giving addresses and phone numbers for them too. This 'three best and rest in a box' technique works for other places as well as restaurants.

One good way to pull your writing into a good structure is to use a spider diagram, so called because it looks like a spider. You put the main idea in a bubble in the middle and draw lines from that to other ideas spread out round it, repeating the procedure from those if necessary. For an article you will only need one spider diagram. For a book you would have one with the title and chapter headings round it, then another for each chapter. Because they are not linear in form, they make it easier to go through your notes and other research material, attaching each set of thoughts to the centre or second-generation bubbles. When you have

finished you can see straight away whether you have an even spread of topics or whether one aspect contains more; this could mean that aspect is worthy of an article of its own. The other advantage of a non-linear form is that it makes it easier to isolate the topic of your opening paragraph. If you have everything listed from top to bottom of the paper, the first item tends to assume prime importance, which it may not merit.

That opening paragraph, and particularly the opening sentence, has to catch the readers' attention and draw them in to read the rest. Sometimes it is called the hook (on which the rest of the article hangs) sometimes the lead (because it leads the reader in). This word is sometimes spelt 'lede', to distinguish it from the metal lead which was used in the pre-computer days of hand typesetting.

Your hook has to intrigue your readers, and that means you have to know who they are. This is why you have to read and analyse any publications you want to write for, as well as check the entries in market directories and absorb what the guidelines say. You do not always get guidelines – many editors will just tell you to read the magazine – but you will find the advertisements will tell you a lot about those readers. Adverts for investment banks, expensive jewellery and luxury cars indicate that the readers will be older, well off and expecting high-quality accommodation plus appropriate activities such as opera, casinos and horse-racing. Adverts for frozen food, the latest popular small car and kids clothing stores mean they will want economy holidays with plenty of entertainment for the kids while mum and dad relax.

So your hook has to speak to these readers in terms with which they can identify, without being a cliché that will turn them off. For this reason, one very effective way to start is by using something that a typical example of your target readers has said, for instance:

- 'Babysitters. That's what I like best. We can go out in the evening knowing the kids are in good hands,' Sue told me as we sat by the pool at the Hotel Paradiso.
- 'I wish I could take some of the staff home with me,' Clarissa said wistfully, clearly suffering from the age-old servant problem. 'They're quiet and efficient – rather different from the au pairs we've had in the last couple of years!' We even had a tray of Earl Grey tea in front of us.
- 'If you get ochre dust on your clothes, be sure to wash it off with cold water, or it'll be there for ever.' This valuable piece of advice was given to us as we set out along the trail round the old ochre diggings near the town of Roussillon in Provence. (This comes from an article I wrote for an American travel newsletter about the ancient pigment ochre.)

Get into the habit of studying the hooks other travel writers use. Here are examples of some of the most frequently found:

- As I drove through the ancient gateway of Wheretown, the winding streets and narrow passageways told me I was going to have fun exploring.
- Thick stone walls and heavy gates at the main entrance to Wheretown spoke eloquently of its history. You only need walls and gates like that if you've had to fight off invaders.
- From my window in the Hotel Paradiso, Wheretown's winding streets seemed to promise many intriguing hours of wandering through the past.
- When the first wave of invaders arrived here in 1286, Wheretown was just a sleepy little village resting beneath the hill. Now, four more invasions and 700 years later, it has turned into a bustling cosmopolitan

city and the hill is covered with the luxury homes of the
shop-keepers who serve the latest set of invaders – the
jet-set who flock here in winter to ski.

• Beat music blared from the cab driver's radio as we
swerved through the streets of Wheretown, dodging
youths carrying equally loud radios. What used to be a
sleepy little village has turned into a pulsating mael-
strom of modern music. The old bull-ring is where it's
at, and I'm here for the first of the weekly pop concerts
that run from June to September.

One type of hook that you rarely see now is the question
addressed to the reader. Rightly so, for it is almost impossi-
ble to start like this without being patronizing. (It also infu-
riates editors if you use it as an opening to query letters;
they might tolerate your assumption that their readers are
naïve, but travel editors expect you to realize that they are
themselves well travelled and sophisticated.)

When you have got your hook right, the rest of your
article should fall into place. Although it will often be
printed with subheadings, each paragraph should flow
on from the last. This can be the deciding factor on
sequence; for instance if you want to concentrate on
restaurants and theatres, you can either end the restau-
rant section with a comment that they are used to serving
an early dinner so you can get to the theatre on time, then
go on to the theatres or do it the other way round,
describing the audience coming out of the theatre and
discussing the play over a late supper after the show.
Such links give much more of the character of a place
than dealing with the two elements in isolation.
Remember that people decide they want to visit a place
because they have read something about it which they
fancy doing themselves: gazing out of their window at
the intriguing streets below and planning an exploration,

being part of the after-theatre supper crowd, going off to a night-club and not having to cut short their fun because they are worried about the babysitter.

As well as all the other things which vary between different publications, the way they like their articles structured can also differ. Although it applies less to travel pieces than others, some newspapers like the opening paragraph to cover everything briefly, then the following paragraphs to expand on the first. This goes back to the days when a late advertisement booking meant space was made by chopping a couple of paragraphs off the end of articles. Magazines now go to print much earlier and their advertising space is finalized well in advance, so they will not lose the sense of an article by having to curtail it. Even so, some do split articles, printing the beginning close to the front of the magazine (where the expensive full-colour adverts and photographs are) and the rest towards the back (where the classified advertisements are and where there is less colour). In this case, you need to put all the punchy, exciting stuff at the beginning and the less exciting detail at the end. Other magazines like to do the whole thing in a two-page spread with the detail or subsidiary parts such as side-trips in boxes.

Another aspect that needs consideration is coherence; each part of your article must contain the same level of information. If you mention that one restaurant is cramped because the tables are close together you should say how much space there is in the others, if you say it is 15 km from town to one attraction you should not say a 'thirty-minute drive' for another distance.

All of this is easy enough if you are only dealing with one town. When your article covers several towns in a region, or several parts of a large city, you will have to decide whether to put all the restaurants together under a general heading of regional cuisine or to deal with each town

separately, mentioning museums, restaurants and sports facilities as part of that town. Again, following precedent in the relevant publication is the safest option but coherence still demands a mention that one town has no restaurants of note when you have mentioned good restaurants in the other towns.

And if one small town features something very different from all the others, especially if all the others are pleasant but do not have anything particularly notable, you need to be careful about devoting too much space to it. If it is that interesting, it is worth an article of its own, but to devote a disproportionate amount of words to it means you have gone off at a tangent. Editors will read your piece and mutter about needing to make up your mind whether this is an article about Egypt or Tutankhamun.

Your wind-up paragraph needs to make it clear to the readers that they have got to the end. The most satisfactory way to do this is a couple of sentences that sum up the whole, followed by a final sentence that implies (without using clichés like 'We'll be back again next year' or 'We had the best holiday of our lives in Whereland') that it was a great experience which the reader would enjoy too.

Here are some possibilities:

- At the end of the first day's pedalling, my legs ached and I wondered if I was going to make it to the end of the route. By the end of the fortnight I was seriously thinking of buying the bike to take home with me. If only I could have bought the sunshine as well.
- It was back to the diet when we got home. We ate so well in Wheretown's restaurants I put on nearly five kilos but I don't regret a gram of it.
- The *Espiritu Sanctu* was a far cry from the dugout canoes

used by the early Amazon explorers, but with guaranteed air-conditioning and world-class cuisine like this, even I could take to the explorer's life.

6 How to Write – Conveying the Experience to the Reader

Using All the Senses

The travel writers who enjoy the greatest success are those whose writing conveys the delights of their own experiences so vividly that readers are filled with a desire to go to the places themselves. To achieve this style of writing, you must first teach yourself to absorb the whole of the experience, using all your senses, so that you can later call up what you have experienced, decide what best conveys the essence of it, and get that down on paper.

Most people use their senses in a very superficial way, often applying a convenient label to objects or sensations, which they then use as a sort of sensory shorthand. Take the humble bicycle: you know what a bicycle is, in a broad sort of way, but could you draw one accurately, or even describe it in detail? How are the wheels attached, where are the pedals, what shape are the handlebars, how is the seat fixed, what about the chain, the spokes, the brakes? If you have ever ridden one, or just pushed one, what does it feel like? Is there a particular smell to new tyres or hot brakes? Is there a particular sound when you apply the brakes? Can you describe the sensation of free-wheeling down a steep hill? Most people could not answer more than a couple of

those questions, but they still think they know what a bicycle is, because they are able to apply that label to the object when they see it.

As any sort of writer, but particularly as a travel writer, you need to be able to do more than that. You need to have exact details in your mind from all your senses if you are to succeed in conjuring up places and events from your memory. Then, in order to convey them from your memory to the mind of the reader, you need the right words to describe them, to bring them back to life.

Let us try something else. How about a plane tree? They are a common sight on the streets of European cities, and in towns or alongside roads in France. What do we know about plane trees, other than where they can be seen?

- They are deciduous, dropping their leaves each year. Their bark peels off in patches, which is one of the reasons they make a good city tree: the newly exposed bark allows the tree to continue breathing in even the most polluted air.
- The fruits are like rough balls on a long stem.
- In France, they are grown alongside roads and in towns to provide shade from the hot sun, and are ruthlessly pruned every year to provide a big canopy of leaves.
- When you drive along a road lined with them, the sound of your car bounces back at you, making a noise which the famous writer Cyril Connolly described as 'sha-sha-sha'.

Put like that, many people who have been to London or France will say, 'Yeah, I've seen them' in a 'so what' tone of voice. What you want them to say is 'Aah, yes', with a faraway look in their eyes as they remember where they have seen them. So let us see if we can do a bit better than the bald statements above.

- It was a murky winter morning in Eccleston Square, the plane trees bald of leaves now, only a few late fruits dangling forlornly from the branches and the patchy trunks damp with mist. I almost expected a hansom cab to draw up and Sherlock Holmes to emerge onto the pavement.
- Strolling back to the hotel after dinner, we paused under the plane trees, looking at the moonlight filtering down through the leaves onto the mottled trunks and listening to the leaves rustling in the breeze, while a night-bird, or maybe a lizard, went 'click-boing, click-boing' in the branches above us.
- Late on Sunday morning we parked in the square, the air full of church bells and a mouth-watering aroma of lamb and garlic wafting from the open door of the restaurant. A small boy, a baguette nearly as big as himself tucked under his arm, scuffed through the curling dry leaves under the ancient plane trees.
- At this time of day, everyone was indoors, except for the elegant madam crossing the street with a neatly coiffured black poodle picking its way over the cobblestones at her side. Two bicycles leaned against one side of the nearest plane tree and on the other side a pool of amber liquid by the gnarled roots started to run towards the gutter.
- Slowing down as we approached another town, we opened the car windows and the plane trees made Cyril Connolly's 'sha-sha-sha' sound as we passed in and out of their dappled shade.

These are word pictures of experiences which I have filed in my head as a multi-sensory 'snapshot'. It is because human experiences encompass all the senses, and because these senses can be conjured up with the right combination of

words, that people want to read about travelling and being in far-away places.

Predictions that television would destroy the market for books and magazines about travel have proved false. Television can let you see and hear a street market but it cannot jog your memory in the way reading can: the sharp citrus scent of a pile of lemons, the curiously heavy feel of a velvety-smooth ripe fig, or the rush of sweetness in your mouth as you bite into it.

There is an interesting psychological theory called neuro-linguistic programming (NLP) which says that many people favour one sense over the others and slant their whole life experience to that sense, to the extent that they not only develop a vocabulary and speech patterns which use words relating to their favoured sense, but develop a lifestyle and living environment which reflects it. So many people seem to fit this theory that it could well be true.

The NLP theory says that people who are visually oriented tend to work in fields which involve colour or design, those who are aurally oriented tend to work in fields which involve sound (drama or music) and so on. Visual people will have immaculate and beautiful homes and clothes, aural people will surround themselves whenever possible with radio or music. Ask them about their holiday in the forest and the visual ones will tell you about the light filtering down through the leafy canopy and the brightly coloured butterflies, while the aural ones tell you about the creaking of the branches and the birdsong.

Fascinating, isn't it? But what has it got to do with writing about travel? You cannot know which category your readers will fall into and anyway, any given piece of writing will be read by all of them. Or will it? The NLP theory goes on to say that people who are heavily slanted towards one sense 'switch off' when presented with information which is slanted the other way. So if your writing is full of

descriptions of colours and shapes, and fails to mention sounds, smells, tastes and textures, any potential readers who are not visual will skim-read your text, fail to find any words which attract them and turn the page.

By describing the whole of the experience, you do two things. First, you ensure that any single-sense readers will find something that attracts them and has meaning to them (and do not forget that the term 'reader' means commissioning editors before it means people who buy the publication). Secondly, for people who are multi-sensory, any writing that only utilizes one sense will seem shallow and unsatisfying, like a meal that is beautifully arranged on the plate but tastes utterly bland.

So as a writer, you need to ask yourself if your personal inclination and thus your writing is towards only one, or maybe just two, senses, then make a point of educating yourself to observe and record all the others.

Nor should you neglect to mention your thoughts on what you are seeing and doing. Typical of this is Dervla Murphy, in her book *Where the Indus was Young*, reflecting on a common dilemma for travellers in the Third World: wishing that modern communication, education and medicines were more freely available to people living squalid lives in remote areas but at the same time regretting that those benefits inevitably bring with them the loss of traditional values and beliefs.

Obviously, your reflections should be appropriate for the publication at which you are aiming your work. If it is a magazine for teenage girls, a comment that the dark-eyed boys leaning on the sea-wall are, sadly, unemployed and likely to remain so in a country deep in recession will get your piece straight in the wastebin when what you should be doing is hoping that those boys will be at the disco tonight, especially the one with the broad shoulders who smiled at you.

The better educated your target readers, the more scope there is for relating what you experience to something else you know. If you know that the trees you are seeing are typical of the limestone they are growing on, you can say so and go on to mention that the smaller plants under the trees like limestone too, and the butterflies are specific to those plants, and the birds are those which eat the caterpillars of those butterflies. Or you can look at a ruined castle in the Pyrenean foothills and even without knowing exactly what happened to it, make a fair guess that it was destroyed during the persecution of the Cathars or the Hundred Years War. These reflections are much more interesting than a mere 'There was a ruined castle on the hill, half smothered with ivy and gnarled trees.'

Naming Things Properly

Some time ago I attended an illustrated lecture at a travel club with the title 'The Land of Genghis Khan'. It was an evening of pure boredom, because not only did the lecturer fail to mention Genghis Khan, he also described everything on the slides he was showing in terms so general that I concluded he was totally lacking in curiosity. The whole audience became more and more fidgety as he told us that at the monastery 'all the monks were inside chanting for hours' (What were they chanting? Why did it go on for hours?), that the bridles on the ponies were made of 'strips of skin' (Was it cured leather or rawhide?), that they stayed in felt tents on wooden frames (I know they are called yurts, but he did not seem to) and that the (unnamed) lake had some (also unnamed) mountains to the north (a precise fact – hooray!).

That was a lecture, but many would-be travel writers do the same thing. They write about 'beautiful flowers in pots

outside the door' when they could say 'pink and lilac petunias cascading from aged terracotta urns on either side of the threshold' or 'The drive was lined with tall trees' when they could have said 'magnificent mature copper beeches'. There is no excuse for this. If you do not know what sort of flower or tree or bird or cow or whatever else it is you are looking at, ask someone. Or take a photo of it and check it in the library when you get home.

I carry a small library of field guides on my travels – birds, butterflies, trees, flowers and crops – but I do most of my travelling in a car which means the weight is not a problem. Even so, if I see something that is not in the field guides and there is no one to ask, I photograph it to find out later. Or, if there is lots of it, I take a sample piece to show people in the hope that they will recognize it. That has led to many a happy hour over a bottle of wine, while the locals not only identify the specimen but also tell stories of their childhood that involve that particular plant (something else to write about).

The point is that the world is full of beautiful flowers, pretty butterflies and nice little birds. But you have to go to somewhere hot to see bougainvillea, somewhere tropical to see humming birds, or California or Mexico to see monarch butterflies. By naming things properly, you help to transport your readers' imagination to the right place, and when they go there themselves they will know what they are seeing and enjoy their travels all the more.

Choosing the Right Words – Verbs, Adjectives and Clichés

Equally as important as finding out and using the proper name for things is choosing the right verbs, adjectives and other words to describe your travel experiences. Using a

limited vocabulary restricts what you can say and thus your writing can only be repetitive and boring. Many beginner writers, aware of this, try to improve their text by using adverbs and adjectives, a trait which has often been referred to as 'adjectival diarrhoea'. Ideally, if you can choose the right word in the first place, you should not need another to modify or emphasize it, and you certainly should not need two. Take, for instance, excited children on the beach. The beginner says they 'ran very fast' down to the sea, the more experienced writer says they 'dashed'.

Although excessive use of a thesaurus can lead to some word choices that appear to be no more than showing off (not to mention those which are close to being malapropisms), it is a good idea to spend some time checking alternatives for the words you find yourself using too often.

You also need to avoid words which other sources use excessively, especially the clichéd superlatives that abound in travel brochures. Pick up a random handful of brochures at any travel agent and you will find they are full of picturesque villages, golden sand, sun-drenched islands, delicious cuisine, de luxe hotels, bustling street markets and intriguing smells or spice-laden air. (In some of the places I have been to, I can think of a better word than intriguing to describe the smells and it certainly is not spice that causes them!)

The point with clichés is that they too are a form of short-hand, convenient to slot in when a description is needed, often when word space is tight. Although in the examples above, of the petunias and the beech trees, the enhanced versions used more words, this is not necessarily the cause of the problem. Article lengths are important, but insufficient room to do justice to every aspect of the scene is usually a problem of focus; try to say too much and you end up saying nothing. Using the vague adjectives 'beautiful' and 'tall' does not do anything to put into the reader's mind

the picture you saw, which is what you should be doing. The whole purpose of this sort of travel writing, where you describe your experiences, is that the readers should end up feeling as though they had the experience themselves. Do not forget that many of them have, and read your piece in the hope that it will remind them of their own experiences.

So ask yourself why you need to mention flowers at all. Does the whole country have them or are they a feature of the specific place? Why this door, in particular? Is this house the topic of your piece, or is it the only one in the street which has pot plants? Is there something incongruous about them: water being used on them in an arid or drought-struck country, or the obvious care being lavished on them when the house itself looks neglected, or the fact that they are the only petunias in a village full of geraniums? To sum up all these questions, what do these flowering plants say about the personalities of the inhabitants?

Answer these questions and you will know how much weight to attach to the flowers, how much wordage they are worth. It also becomes easier to pick the right words and the right sentence structure to describe them.

- ... potted geraniums outside every door.
- Determined to win the *ville fleurie* title for the fifth year running, the villagers have filled every surface with flowering plants; marigolds in the horse-trough, daisies in old churns outside the dairy, geraniums in plastic pots by the fountain, and at the Town Hall, pink and lilac petunias cascading from aged terracotta urns on either side of the threshold.
- ... an old woman, clad in rusty black, dribbling precious water on to her petunias from a battered teapot.
- 'Pah,' said Frau Gruber, 'if the landlord wants to let the house fall down, I don't care; I shall move in with my daughter. But while I am here, I will have my flowers.'

114

- ... and amongst the petunias, a plant with leaves like outstretched fingers. I asked what it was, and the man glanced quickly up and down the dusty street before answering. 'Do you not recognize them, Señora?' he asked, and he winked. 'You cannot smoke flowers ...'

It took over an hour to write and rewrite those five descriptions until they gave the exact feel of the atmosphere I had encountered. The first is short and matter of fact, a mere passing comment about a commonplace sight. The second is meant to convey not just the reason for all the flowers, but also the exuberance of the planting and finally hint that the workers at the Town Hall consider themselves a cut above the rest of the villagers. The third, by mentioning 'rusty black' clothing and 'battered' teapot, together with the verb 'dribbling' and 'precious water' tells you that the old woman, and by implication, her fellow inhabitants, are impoverished and thrifty. The fourth shows an independent old woman determined to keep control of her own life for as long as she can. The fifth is intended to convey a frisson of excitement at visiting a rather raffish town in what the use of 'dusty street' and 'Señora' should tell you is Latin America, where the inhabitants are not above fooling the law but are still innocent enough to draw visitors into the conspiracy. You could feel rather naughty by going to that town while still feeling safe in a place where the criminal inhabitants wink at you.

Look at the second and fifth examples again and notice how the words and the sentence structures work. The second starts with fairly short words, most of which have only one or two syllables. This, together with the workaday objects used to hold commonplace plants, serves to emphasize the slightly frantic nature of the competition and the simple aspirations of the villagers. The penultimate phrase 'and at the Town Hall', by using only single-

115

syllable words, signals a change of pace and mood. Not here the common bright plants and makeshift pots or anything as vulgar as a mere doorstep, but pastel coloured petunias (four syllables) cascading (three syllables) from aged (and thus valuable) terracotta (four syllables and superior to mere clay) urns (superior to mere pots) on either side (implying a matched pair of urns) of the threshold (clearly a superior entrance).

The fifth piece works the other way round. It starts gently, with phrases structured to appear innocent, then equally innocently signals the change of pace with a sequence of short words ('I asked what it was.') The man might have 'looked about him', but instead his furtiveness is emphasized and the pace quickens: he 'glanced quickly' (verb and adverb both chosen to emphasize the speed of movement) 'up and down' (emphasizes the fact that he is checking for potential eavesdroppers) 'the dusty street' (itself a cliché, but one which serves to emphasize the scruffy nature of the place) before answering. A distinct feeling of conspiracy comes from his question 'Do you not recognize them, Señora?' and the wink. The wink, by breaking up what he said, emphasizes the conspiracy and sets the reader up for the punch-line which, without actually saying so, makes it quite clear that the mystery plant is cannabis.

One thing that none of these pieces does is to patronize the people we are observing. This is one of the great 'no-no's' of travel writing. While there undoubtedly are people who consider themselves superior to 'the poor bloody natives', they are mercifully few and far between these days. Most people are embarrassed by patronizing writing; reading it makes them feel uncomfortable and they stop reading. Editors know this, so they don't like it either.

Of course people in other countries are different – that is half the fun of going there. At the same time they are much

like us, with all the hopes and aspirations and foibles of any human being. And that is the whole point of reporting these little scenes and exchanges; they point out the foreignness but at the same time they comfort the reader with the reflection that after all, foreigners are just like us. How can you possibly be frightened of people whose children kick at a pile of leaves and whose elegant ladies have dogs which piddle on the street?

Show, Don't Tell

A tip to help you bring your own experiences to life as someone else reads them is to remember the old adage of the creative writing tutor: 'Don't tell me what happened, show me it happening.' Another of the problems of the 'we went, then we went ...' style of writing about a holiday is that it invites the writer to drop into 'tell' mode. Here is an example, of seeing a girl waiting for someone outside a café: 'We settled at one of the tables outside a café to watch the world go by. There was a girl at the next table who we thought was probably waiting for her boyfriend. She seemed anxious'. You can convey that obvious anxiety much better by showing us the symptoms instead: 'The girl at the next table checked her watch again and tapped her index finger on the tabletop, peered down the street towards the station and looked at her watch once more.'

What has all this to do with a travel experience? It helps you show that these cafés are places where interesting things happen and it is another of those experiences that everyone has had, that makes them say, 'Oh yes, do you remember that café in Wheretown when we ...?'

There are several aspects of travel experiences which are particularly prone to the 'tell' problem, including people and animals, the exteriors and interiors of buildings, food

117

and drink, the weather and scenery. Saying 'The mountain scenery was spectacular' and 'We had another delicious meal' does not tell the reader anything, any more than references to beautiful flowers.

What was it about the mountain scenery? Were the mountains old and worn down like the Appalachians or young and rugged like the Himalayas? Were there sharp peaks silhouetted against the sky, did the range march majestically to the horizon, were the lower slopes clad in trees and the upper slopes exposed rock, with a dusting of snow on the very top? Was there a glacial cirque below one peak, and the typical U-shaped valley below where you stood, with brown and white cows grazing in the fields and the clonk of their bells wafting up to you on the breeze?

What about the meals? Were they waiter service, a buffet, with tables groaning under joints of beef and ham, platters of langoustines and oysters, great dishes of green salad with radishes and twists of cucumber, sliced tomatoes sprinkled with basil, potato salad with a sour cream sauce, then ices and alpine strawberries and a purple-black berry with a taste like sweet wine and an unpronounceable name which they said came from only one local valley?

One useful technique to help you with all of this is to imagine that instead of writing, you are making a film. Think how films (cinema or television) work: action scenes like water-skiing or snow-boarding are a series of short sequences, with the participants appearing suddenly and moving quickly across the screen. Scenery or buildings start with long shots, panning slowly in or across, dwelling lovingly on details as they come into focus. A large bird might soar above the mountain or a plane leave a silent con-trail across the blue sky, emphasizing remoteness. In the close-ups of trees or wild flowers, smaller birds or insects move faster, helping to give a feeling of busy-ness and intimacy. The soaring bird might give a drawn-out

screech; in the close-ups of vegetation the flutter of feathers and the buzz of insects would be heard, as well as the dissonant clang of the cowbells, perhaps with some shots of the cows' heads as they crop the grass.

On the screen, you demonstrate pace with the length of the shots. Slow pace means lingering shots or slow pans, avoiding fast-moving elements close to the camera. Fast pace, short sequences, camera chopping from one shot to another, with fast-moving subjects close up. On paper, you do the same thing with the length of the words and sentences and the structure of the sentences, as I have done above. Long, multi-syllabled words and multi-phrased sentences give a leisurely feel, short words and short sentences give a feeling of urgency.

Point of View

Sometimes called viewpoint, this is writers' shorthand for the person who is narrating. There are three possible viewpoints: the first person 'I' or 'we', the second person 'you' and the third person anonymous narrator. The third person form means the narrator can report the actions and observations of various people in turn or make general statements, but in the first person can only know his or her own experiences and what other people have said, which must be labelled as such by comments like, 'Tom told me ...' There is a rule in fiction that you should never switch between the first and third person and that you should not back away from the story to deliver relevant facts in a mini-lecture.

Whilst you should not do it too often, as it gives a choppy feel to the writing, it is perfectly acceptable to do this in travel writing, especially in the lead paragraph. Look back at the examples of hooks on pages 101–2 and at

your travel cuttings and you will see how it works: a brief statement about the place sets the scene before the 'I' of the writer arrives. It is like the way people speak, they intersperse factual statements with the story of their own involvement.

The current trend is for the first person viewpoint, where writers tell you about a place through their own experiences. It is a viewpoint that invites the reader to identify with the writer and it has great immediacy, but it is, of course, subjective. It will only work if you are able to identify with the target audience. The same applies to the second person, where the writer says, 'You will find the boat ride thrilling' rather than 'I found ...' It can become cumbersome and it invites the response, 'How do you know I will find it thrilling?' It is a viewpoint that is now rarely used.

The third person viewpoint is much more objective and often more formal, although it can still report subjectively by saying, 'Most passengers on this boat found the trip thrilling.' It works well when space is restricted and you want to get a lot of facts across in a small space.

Some pieces, such as the one on Goya in Madrid mentioned earlier, can be written in any of the three persons. The first person would say, 'I went to Madrid to see the Goyas, starting at the Prado', the second person would say, 'Start at the Prado then go on to ...' and the third person would say, 'Madrid is the home of many of Goya's paintings, housed in collections at the Prado and nine other galleries.'

All of these viewpoints can be used in travel books, as appropriate to the sub-genre. However, there is one thing you do have to be careful about when writing a first-person account of a long journey. In a short piece you do not have the space or the time-frame to give more than an indication of what sort of person you are. Over a longer

time-scale it is usual to reveal much more of yourself: your philosophy, your hopes and fears for the future, how you have conducted yourself in the past and how you respond to stressful situations on the journey you are describing. No one will believe you if you present yourself as superhuman and it is expected that you will faithfully report some of your own foibles. You would not be human if you did not have them, but do take care not to overdo this aspect. Your readers need to be able to identify with you, and they will not want to do so if you reveal yourself as having a nasty temper or a streak of spitefulness.

Writing for the Internet

It is generally accepted that writing for the Internet needs to be in short 'bites', with a punchy style. The assumption is that most people who use the Net and other forms of electronic media have short attention spans and will not read anything which is not split into short paragraphs and interspersed with numerous pictures (and, says the cynic, plenty of advertisements).

Some of this is due to the fact that although websites are divided into what are called pages, you do not actually get very much space on a screenful. Rather like a printed document which lacks white space, solid blocks of text (which in this case would cover the entire screen), are extremely daunting. Of course, many print magazines are adopting this short-bite format for the same reason: short attention-span readers.

But as far as e-media are concerned it is early days yet. At the time of writing a very high proportion of web users are young and perhaps impatient rather than permanently stuck with short attention spans; they may

come to appreciate the more thoughtful, longer pieces. Meanwhile, the more patient older generation is joining the web in increasing numbers. The whole thing is in a state of flux. For the writer, the only advice I can give is to keep logging on and watching the trends.

7 Illustrations

Unless you are a talented artist and your market is geared up to using line drawings or paintings, illustrations generally mean photographs (often called 'pics'). These may be available to the publication at no cost from tourist offices and other interested parties, or they may have to be paid for, from photographic libraries or straight from the photographer.

The glossy magazines need equally glossy photographs and often commission professional photographers to take the photographs specifically to accompany an article. This does not mean the photographers part with the copyright, and those photographs, together with any others the photographers may take on their own account, will be made available to other publications for a fee. Some photographers administer this themselves, others do it through photographic libraries. The economics of this are such that the photographs need to earn their keep, so the libraries prefer shots which they know can be used over and over again; for this reason they tend to be of popular places and obvious subjects.

When you submit articles about less usual places or subjects, there will not be photographs available in the libraries, and if the magazine has a tight budget they will not want the expense of commissioning a photographer to

take a set. In this situation, if you can produce your own photographs they will be happy to use them and pay you for that use. Indeed, in many cases it will only be the fact that you offer pictures to go with your words that makes them accept your work. Some of the pictures which put me in this position were of the 'fungus' playground in France and others of a pumpkin festival.

The Practicalities of Taking Photographs

If you are already an experienced and talented photographer, you can skip the next few paragraphs. If not, read on. With modern automatic cameras, anyone can take a good photograph. You do not need to pay a fortune for these cameras, nor do you have to know about focus and apertures; the camera does all that for you. Most of them have a two-position shutter: you press the button half-way and the camera focuses and beeps to say it is ready, and you then press the button the rest of the way. If the camera thinks there is insufficient light, it will blink an indicator at you within the viewfinder. And that is it. Experienced photographers can switch off these automatic functions and make their own adjustments. You may feel the need for an additional lens such as wide angle or telephoto, but these cameras normally come equipped with a general purpose lens which will serve for most purposes.

Apart from the camera, the only other essential piece of equipment is a tripod. The problem with snapshots, especially for inexperienced photographers, is that it is very easy to jiggle the camera as you press the shutter. There is also the dreaded 'camera shake' which comes as your arm tires. With a tripod you can eliminate all this and it also allows you to take your time composing your shot. A proper tripod is best but there are two alternatives if space

and weight is a problem; you can get a telescopic monopod which, although it does not allow you to let go of the camera, does give some stability; or, if there is a handy wall or car to stand it on, there is the humble bean-bag, which allows you to rest the camera in a situation where it would otherwise slip.

There are many types of filter available. You do not really need any for casual pictures, but a Polaroid filter is useful if you want to take shots of things under water (fish, for instance) and many photographers suggest that you keep a plain glass (sometimes called a 'clear view') filter on the camera at all times when not using another filter. These filters help prevent the lens from fogging up in changeable temperatures and will protect it from dust or from damage if the camera is dropped. (Wise photographers keep the strap round their neck at all times when the camera is not on a tripod.)

It is wise to carry a couple of spare lens caps; no matter how assiduously you put your lens cap in your pocket, there will inevitably come a time when you are distracted and put it down, never to see it again. It's also sensible to carry a spare battery, or put a new one in the camera before you set out on a trip.

If you have a lot of expensive photographic equipment, make sure it is properly insured for foreign travel, and carry copies of the invoices in case you have to produce them for Customs. This does not apply within the EU, and you may find it worthwhile buying your equipment on the continent where it is considerably cheaper than in the UK. Film is not that much cheaper abroad and it will probably not be process-paid.

As a general principle you should carry cameras in something that is not obviously a camera bag and thus attractive to thieves. Anything that has a little padding and a couple of zipped pockets will do, such as a duffel bag or airline tote

bag. Do not put exposed film back in the camera bag, no matter how inconspicuous it is. You can easily buy another camera but you cannot easily replace a batch of photographs.

If you are going to take photographs at all, take a lot. It is a false economy to take just one of each shot. Selling just one picture should earn you more than the cost of buying and processing the whole film. There are so many things that can go wrong with any given shot, from inadequate light to someone moving into shot at the crucial moment, not to mention the picture which an editor loses when you need it for another magazine. Take at least three of every shot and if your camera has a 'bracket' facility (three separate shots on one press of the shutter, each at a slightly different exposure) do it twice. Professional photographers call these 'camera duplicates', a cheaper option than having your photographs copied.

It is also a false economy to delay changing film when you find yourself at the beginning of a situation where having to stop shooting and change films will make you miss crucial shots: during an ostrich race, perhaps, or a prize-giving. Editors like to be offered the complete sequence of such events and it would be a pity to miss this chance just for the sake of saving two or three frames of unused film.

Deciding what equipment and film to take is part of your pre-trip homework. Although you cannot know exactly what you will find to photograph, you will be able to get some idea of what is there: scenery, people, fast-moving events, the levels of sunlight, lush greens or arid browns. If in doubt, consult the shop where you buy your film.

What Sort of Pictures to Take

More homework before you go, this time studying the

photographs in travel magazines and guidebooks, will give you a good idea of what editors like. Pay particular attention to the photographs in magazines you hope to write for and notice how those shots are composed. Do they favour intimate close-ups, grand scenery, lots of bright colours, crowds of busy people? Then, when you arrive at your destination, try to spend a little time in the tourist office looking through the slides and postcards they have on show, and ask which of them will be available for use at no charge. There is no point in taking your own pictures if the magazine then obtains them free from elsewhere, but you will endear yourself to the editors if you tell them these free illustrations are available.

The pictures you do take should be shots which do not look like the clichéd shots you see everywhere (lavender fields in Provence, Flamenco dancers in Spain, floating markets in Thailand), but which still give the flavour of the place. Remember that it is the little details and the unexpected that bring out the ambience of a place: neat rows of lavender going up a hill are impressive but it is the shot of an aged Frenchman sitting under a tree at the edge of the field with his bottle of wine, baguette and chunk of cheese laid out on a handkerchief that makes the shot memorable, or the tired Flamenco dancer sitting on the edge of a fountain with her shoes in her hand, her feet in the water and an expression of relief on her face.

Your pictures should support what you intend writing about. This is the essence of professional photography, that every shot you take is for a specific purpose. You are taking pictures for publication and you have to be ruthless about ignoring everything that will not serve that purpose. A medieval festival with everyone in costume? Ignore the one who is wearing glasses or standing in front of a television shop. A picture of your car in front of a popular view? Not unless you will be writing for the car manufacturer's

magazine. A natural disaster of some sort? This is possible, but it is not what you are there for. If it is a major disaster, professional news photographers will be flown in and you cannot compete with them. If it is not too bad, and you know a likely market *and* you are on your way home so that you can get the pictures to them fast, maybe. Phone first and ask.

When you have gone somewhere for a special subject, take lots of shots of all aspects of it so that editors can show a sequence or a selection of large and small shots. If the event is unusual enough, you will be writing several pieces about it and it is tactful not to offer identical shots to every editor. Typical of such events was a pumpkin festival which we attended in France. The whole village was given over to the festival, with some 400 stalls in the streets selling everything you could think of to do with pumpkins, from seeds to dried gourds, huge or tiny pumpkins, and things to eat made of pumpkin. There was a giant pumpkin competition, a wonderful blue-painted farm cart tipped up on the green so that its load of pumpkins flowed out onto the grass, a parade with Cinderella in her pumpkin coach, and children with their faces painted golden yellow. We took over a hundred pictures of the event; among the magazines I wrote it up for was *France* which printed a selection of them as a montage on one page as well as two more elsewhere in the article.

You will probably have more success with this sort of picture than with photographs of scenery. Intimate shots of a house or barn and a couple of trees are fine (although always improved if there is a human or animal in them) but grand vistas or distant views are rarely successful without special lenses and a lot of know-how. If you really want to do this sort of thing, sign up for a photographic holiday led by a professional landscape photographer, but do not expect to sell many of the resulting pictures to anyone but

small magazines; the professional will be taking his or her own shots as well as instructing.

Do not forget to take portrait (vertical) as well as landscape (horizontal) shots, especially if you see something spectacular enough for a magazine cover. In this case make sure there is plenty of sky or soft focus at the top, where the title will go. Pictures which are the wrong shape can be cropped but this could spoil your carefully balanced composition.

With a camera that does all the technical bits for you in your hand and a photogenic subject in front of you, you then have to do the most difficult bit: composing your picture, or rather putting yourself in a place where the composition is at its best. The knack of 'seeing a picture' is not something you are going to pick up from reading this but one thing which might help is to remember the artist's 'two-thirds, one-third' rule. This says that the point at which the eye focuses (the main point of interest) should not be in the centre of the picture but two-thirds of the way along and one-third of the way up or down.

This is easy enough with pencil and paper, but needs a slightly unusual technique with an automatic camera, which will want to place the focal point in the centre of the picture. You will have to read the manual for your camera to check exactly how to do this, but basically what you do is ask the camera to focus on your chosen item by pressing the shutter to the halfway point with your focal subject central, waiting for the beep, then moving the camera, with the shutter still half-pressed, until your chosen subject is where you want it to be before completing the shutter press.

There are several things you should know about taking photographs of people for publication. If you want a portrait shot of an individual or small group of people, it is polite to ask if they mind. You will occasionally come across people in major tourist centres who make their living from

this and who want to be paid, but in general the main problem is that people who know you are taking their picture will insist on posing and the result is often rigid and unusable. If you anticipate taking a lot of this sort of picture, you might do better to use a telephoto lens and get them from a distance, or invest in a motor drive and get them as they go about their business.

Most people in most countries are perfectly happy with the idea of appearing in magazines or books, and most magazines in most countries accept this. In America, however, there is a growing trend for magazines to ask you to produce signed permissions from people whose faces are clearly shown. Given that signatures on the standard forms may be difficult to obtain, especially if your command of the local language is less than perfect, you may prefer not to take this sort of picture. The American market guide *Writer's Markets* shows which magazines require these forms.

There are also some countries where you have to be extremely careful about taking photographs of buildings, or even scenery when the sky happens to include a passing aeroplane. Your innocent intentions may be misinterpreted if you are anywhere near a military establishment or other secret installation. If in doubt, ask first. Note also that in such super-sensitive countries, it is not wise to tell anyone that you are a writer, as they might interpret this as 'trouble-making journalist'.

Even where such political sensitivities do not exist, you may find that you are not allowed to take photographs of banks, and you are hardly ever allowed to take casual photographs in places of worship, art galleries, museums or archaeological digs. You may be allowed to do so after obtaining written permission, and by appointment, but even so they do not like the use of flash. In this country, large organizations like the British Tourist Authority,

English Heritage and the National Trust will only let you take photographs inside their properties (including the grounds) on payment of a substantial fee. They would actually prefer you or the editors who use your work to use their own library shots, also on payment of a substantial fee. Theoretically they cannot prevent you taking long-distance shots from outside their boundaries, but they may cause enough fuss to make you unpopular with editors. Some private property owners, especially those with famous gardens, have now caught on to the amounts professional photographers get paid for photos and they too will ask for a fee for the right to take photos.

What Editors Want

Almost all publications use 35 mm colour transparencies (never colour prints) and the few that do print black and white do not mind getting them from colour transparencies, so it just is not worth carrying both and messing about changing film or carrying two cameras. If you will only be taking a few pictures on a trip, it is fine to buy process-paid film and send it off for processing, as long as you can specify the type of mounts used. What you emphatically do not want is plastic mounts with glass inserts. These inevitably break in transit, damaging your precious photos in the process (or even the unfortunate editor, who is not going to like you if it happens). Plastic mounts without inserts are tolerable, but you cannot write captions on them. The best are cardboard mounts.

Best of all is to do your own mounting, because then you do not have to pay to have useless shots mounted. If you buy your film, and the mounts, from a professional photographers' supplier, it will come without the processing charge (as well as being generally cheaper), and the

supplier will be able to recommend a processor who will give you back the processed film in a single strip. They will also, and this is a major advantage, make sure that they have brought out the best from your film, instead of just putting it through an automatic machine without adjustment. If you mount every shot, you will still have paid less by doing it this way than by paying for the processing in the cost of the film. The other advantages of buying non-process-paid film are that you only have to pay for the processing when you have it done, not when you buy the film, and that you may be able to get them processed on the spot, thus saving the unprocessed film from a burst of X-rays at the airport.

When you get the processed film back, cut it into frames and mount the good ones. You need to be ruthless and throw away any shot that is not good enough to be offered for sale. There is no point in keeping them and they just take up valuable space.

You do not necessarily need to do the final captions at this stage, but you do need to make some notes on what is in each shot while it is still fresh in your mind. I mark my slides with a unique number made up of two digits for the year, two or three digits for the number of films used since the beginning of the year, and two digits for the number of the frame within the film, thus: 99/83/12. Then in a database file against the number it says '23 July, lavender harvest near Sault, Provence, Mr Hugon enjoys his lunch'. I carry a notebook with the camera to record details of each shot when I take it. I also use that notebook to give me the number of the film; I write the number on a page then take a shot of it at the beginning of the film. You can buy a 'data back' for your camera which adds the date and time of each shot to the film, but these are costly and my method works well enough.

The best way to store transparencies, and to send them to

editors, is in plastic presentation sheets. The big advantage with these, apart from the fact that they hold the transparencies snugly, is that the editor can lay the whole thing on a light box to look at them. The presentation sheets hold twenty transparencies and you rarely need to send any more. (You do not have to send this many; it is better to send ten good shots on their own than to fill the spaces with mediocre shots which devalue the impact of the good ones.) Never send transparencies loose in an envelope, as they might fall out on opening and do not send them in the plastic boxes the big processors use. Editors are just not going to mess about with loose slides one at a time, and you do not want them to come back with thumb prints on, either.

Always send a good selection of shots, from long-distance ones to close-ups, and in a variety of hues. Even though they may only use one, if you send in a batch that are all the same hue the picture editor may decide that they look monotonous at first glance and not bother to look closer.

Make sure that the presentation sheet carries your name and address and that each transparency is marked with your name and the copyright symbol (I have a stamp with these on), plus a unique number that links it to a list of captions. Of course, if you have neat writing and cardboard mounts, you can write the captions on the mounts. The transparencies should be accompanied by a letter stating what you have sent, what rights you are offering (usually one-time rights only), that the responsibility for them passes to the publication when they receive them, and that they are to be returned in the original mounts and in good condition. Send two copies of this letter and ask for one to be signed and returned immediately in agreement of these terms and conditions. Alternatively, you can buy sets of printed forms from the British Association of Picture Libraries & Agencies (see the Appendix for the address).

If you do take black and white pictures, ask what size the prints should be (usually 20 x 25 cm), and whether they like matt or glossy. Captions should be on a label stuck to the back of each picture, never written on it, as this may mark the face. Never send the negatives.

Always send transparencies or prints in hard-backed envelopes or with a stiff piece of card inside, and mark the envelope 'photographs, please handle with care'. You can buy hard-backed envelopes with this message printed on them. Send them by recorded delivery and insure them for consequential loss. Only experience will tell you what each shot is worth, but it should be a minimum of £50. When you have to send original photographs abroad, mark them 'press photographs, no value' on the green customs form, so that the recipients do not have to pay duty on them.

However, neither original transparencies nor prints should be sent until specifically requested. Apart from the risk of loss or damage, you may not get them back for months, during which time you could have sold them to someone else. Instead, for black and white send a proof sheet, for transparencies send a laser copy, which you get from your local print shop. These are expensive, so although there is no point in sending return postage for an article, which can be reprinted for less than the cost of a postage stamp, you should send return postage for these laser copies. Of course, if you have the relevant computer program and colour printer, you can produce your own copies easily, or even send them by e-mail.

Selling Photographs on Their Own

If your pictures are good enough, both technically and in their subject matter, you may be able to sell them on their own. The likeliest markets for an amateur photographer are

specialist magazines such as *Walking Abroad* or *France*, tourist offices or travel book publishers, especially guidebook publishers. Other possibilities are tour operators, airlines and car-hire or ferry companies, all of whom need photographs for their brochures and if your own interest involves special equipment such as horse-riding clothes or camping gear, the manufacturers of that equipment, who often find it difficult to obtain good photographs of their products in use in genuine situations (i.e. not posed with models).

What you do is send a letter saying you have a good collection of photographs of whatever and mentioning some of the places your pictures have been published. Enclose a few sample copies so they can see the quality of what you have, and offer to send a full list of all available shots.

As an alternative to sending laser copies, many photographers now upload sample shots to their personal websites for viewing by editors, or use their computer to put some shots on a CD-ROM and send that.

For more information on markets for photographs, read *The Freelance Photographer's Market Handbook*, published annually by the Bureau of Freelance Photographers.

You may be able to submit your photographs to a library, but this has some inbuilt difficulties, not least of which is that they want the exclusive right to them, which means you cannot offer them to editors to accompany your written work without their having to pay the full agency fee. Libraries will also only accept very high-quality pictures and are not interested in a few at a time. The first batch will have to be several hundred and they will want an ongoing supply of large quantities at regular intervals. They will also want an agreement giving them use of the pictures for a long period (often several years). They pay you half of what they get for the use of the pictures.

How Much Will You Get for Your Pictures?

Payments for the use of photographs is based partly on the likely circulation of the publication, but mainly on the size of the reproduction, which is expressed in terms of quarter, half or full page, or double-page spread. Newspaper front pages, magazine covers and book jackets should pay 50 per cent extra. Colour pays double rate for black and white. To obtain an indication of current rates, consult the NUJ's *Freelance Handbook*. You do need to know the current rates, as some mean editors will try to underpay you if they realize you are not a professional photographer. As with articles, if you are selling photographs on their own, you may need to send an invoice.

Other Sources of Photographs

Most writers do not consider it part of their job to source photographs to illustrate their work, but there are some occasions when you might be asked to help with this. The more specialized the subject, the more likely you are to be the best judge of what is needed. When a short piece of writing and only a few pictures are involved, you will do it as a courtesy to the editor, but if it is going to be a major task taking up a lot of your time, you should ask for a fee. You are, after all, saving the publisher the cost of a professional picture researcher.

What you should avoid, in situations where the pictures have to be paid for, is having them delivered to you direct from the source. It is one thing if the publisher sends you a batch to choose from, as they will have signed an agreement accepting responsibility. If the pictures come straight to you, you will have to accept that responsibility and run the risk of having to pay for any which the publisher subse-

quently loses (which some are very good at doing).

There are many sources of free pictures. Tourist offices usually have plenty, as do PR companies and various commercial organizations such as tour operators. The PR department of the French company which runs the motorways I mentioned on page 26 sends me regular batches of transparencies because they know I continue to write about them. These are copies and they are not concerned about having them back. The clients of PR companies and other commercial companies expect to have their name in the caption unless the whole article is about them; even then they expect the pictures to be credited to them.

If you are offered photos to use free, you should check that the copyright in them belongs to the person who is offering them, or you might later receive a bill for their use from the photographer. Copyright in photographs is the same as in writing: it automatically belongs to the photographer/writer unless they pass ownership to someone else. What is normally sold is not the copyright of the pictures or words, but a licence to use them.

With the advent of digital photographs (also called images), it is now possible to transmit pictures via computer. This is normal practice for most websites and Internet service providers, and if you are involved in organizing photographs to go with your words in such a situation, it is best if you just ask the image provider to transmit a selection of images direct to the online editor. They will then sort out the permissions without involving you, and they will also receive the images in a form they can use immediately.

Another possible source of free, or at least inexpensive, images has recently arrived on the scene. Multi-media companies have been buying up the stock of entire photo libraries and converting them to digital format on CD-ROMs which you can buy for a few pounds. With the right

software on your computer you can view these images and copy the ones you like to a disc for the publisher. Do, however, check the licensing agreement on the box to see whether the images are free for unlimited use or are restricted to non-commercial uses.

Digital Cameras

These are the latest development, and for absolute beginners they may seem like the answer to taking photographs. However, the results you get will still depend on your skill, and how much you pay for the camera (although like everything new, prices are dropping rapidly and the quality is improving equally rapidly). You also need some skill and the necessary computer programs to convert the contents of the camera into something you can send to an editor, always assuming that editor is organized to use them. It will not be long before they all are, but it would be wise to enquire before making the assumption. As a general principle, the larger the publisher, the more likely they will be to accept these images.

Non-photographic Illustrations

In a very few cases, book publishers and magazines will use line drawings or water-colour or acrylic paintings. They normally commission these from commercial artists, but if you are talented enough they might use yours. You should negotiate a fee for these commensurate with the amount of time they took you to produce.

It is more likely that they will ask you to supply or recommend maps. If you recommend a published map, your publisher will deal with any licensing fee. If you draw

your own original maps, the copyright in them is yours and you negotiate a fee as above. Obviously, the simpler the map, the less you will be paid for it. Strictly speaking, you should not create your map by tracing it from a published map, but no doubt this often happens.

As with photographs, there are now numerous maps available on CD-ROM and for downloading from the Internet, and as before you should check the licensing agreement before using them.

As with photographs, you should not send original artwork until it is requested (send photocopies instead), and when you do send it, it should go recorded delivery and suitably insured.

8 Arranging Your Trips

Understanding How the Travel Industry Works

It might not affect the way you put words on paper or screen if you do not know how the travel industry works, but it will make a difference to your credibility with editors if you make naïve and incorrect assumptions, and it is certainly relevant to your dealings with tourist offices and the various commercial organizations who operate in the industry. You can teach yourself most of what you should know by reading textbooks on travel agency practice; what follows is a brief overview.

Never forget that everyone is doing what they do (selling a product or service) to make money. This applies even to the tourist offices, although they do it indirectly. They are funded by their governments to encourage people to visit their country and spend money. Like anyone who is selling something, all these organizations understand the need to advertise, and they do this in the various media where you sell your writing. They advertise directly, by placing adverts and paying for them, but they know the customers take advertising with a pinch of salt, so when someone provides indirect advertising by mentioning them in an article or guidebook they are delighted. This is why all the elements of the industry are always pleased to help a bona fide travel writer.

In this context, travellers are divided into those business people or holidaymakers who travel independently, and holidaymakers who buy an organized package. The independent travellers may organize all the components of their trip themselves, contacting each carrier, hotel and restaurant to book what they want in advance or just turning up and organizing it on the spot; or they may instruct a travel agent to do it for them. Packages are also sold direct to the customer or through travel agents. Like any other sort of agent, travel agents receive a commission from the suppliers for each customer they book.

The package tour operators work like this: they decide what will make a desirable holiday (let us say it is seven days in Madrid), including the flights, buses from airport to hotel, hotel room, meals (some in the hotel, some in local restaurants or night-clubs) trips to local attractions or sporting activities, then the bus back to the airport and the flight home. Then they make an educated guess as to how many people will buy this holiday and when. Let us say the operator decides that twenty people will buy for each week in July and August.

With very few exceptions, the operators do not own the hotels or component providers, as you will realize if you compare a sequence of similar packages. For instance, there are six or more UK-based tour operators (let alone those in other countries) offering horse-riding safaris in Kenya, but only a couple of ranches providing the horses and guides.

So the operators go to an airline or charter company and book twenty seats on flights to Madrid, go to hotels and book rooms and meals, go to the night-clubs and book tables for meals there, book the buses for the airport-hotel transfers and so on. Whether or not the right number of people buy the packages each week, the operator is committed to paying something for what has been booked; at the very least a booking fee, and often more than this.

141

This is why package holidays can often be bought very cheaply at the last minute, as the operators try to get some money in for all those components which they have to pay for.

If tour operators end up with unsold packages, particularly outside the main holiday season, they may be happy to offer them to a travel writer at a heavy discount or on a complimentary basis. The same applies to the providers of the various services and products, but not to ordinary travel agents. (Remember that agents only earn commission on the products they actually sell, so they have no incentive to do anything for you other than arrange your personal bookings.)

Much of this organizing and booking is done at the World Travel Market and other trade fairs throughout the world, or as a result of contacts made at those fairs. In many cases, tourist offices will help organize these bookings (mainly for small privately owned businesses in their immediate area), and they know which operators and travel agents in which countries are bringing people to their area.

This is information you may need, as your readers will want to know how to get to the places you write about, especially when you are writing for magazines in a country which does not share a language or currency with your target location. I first encountered this when writing about Cavaillon (Provence) for an American newsletter. The editor pointed out that readers would not want to make their own arrangements in France itself, with all the complications of the language and having to send reservation fees. With the help of the Cavaillon Tourist Office, I was able to provide contact details for some American-based travel agencies which specialized in that town.

Tourist offices will do many other useful things for you. They will send general or specific brochures, find particular

information if you ask nicely and, when you visit, will provide you with introductions, will often drive you round to places of interest and translate for you, and will quite often pick up the bills.

There are package-tour operators at all levels of industry, from the two-week lager-lout specials to Benidorm to the up-market 'round the world on Concorde/QEII/luxury train' trips. They have all sorts of specialities, from adventure holidays to 'great rail journeys', as well as garden, art, music or photographic tours complete with professional lecturers. Some deal with their publicity themselves, others do it through PR companies. The same applies to the large-scale individual component providers: the airlines, ferry companies and hotel chains. Part of the learning curve when starting as a travel writer is finding out who has their own press office and who uses which PR company.

Ask all of them to add you to their database so you get regular updates on what they are offering and, when you get something published which mentions them, do not forget to send them a copy. In the case of organizations represented by a PR company, send it direct to the PR company, not to their client. They will pass it on to the client as proof that they are doing their job and will be grateful to you for providing them with this proof. If you send it straight to the client company, the PR company may not get the credit. Sending copies of published articles is not just a courtesy, it is part of maintaining your bona fides and it will help keep you in the forefront of their minds when they are organizing press trips, publicity lunches or other 'jollies'.

Organizing Your Trips to Get the Most from Them

When you start out as a travel writer, you will probably not have any specific assignments for magazines and will

basically be going to see what you can see (although you should always have some plan in mind). This means you need the freedom to do your own thing, rather than ending up in a regimented situation, where you are expected to go along with the crowd. This does not stop you buying an economically priced package holiday, but it needs to be the sort that delivers you to the place, provides you with a bed and some meals and then leaves you in peace, rather than something like a coach tour where you have to get back on the coach just as you have discovered something fascinating.

Do make sure you do not choose the one week in the year when all the local businesses are closed, such as the Italian August week of Ferragosto, when even the restaurants close, or when there is a long public holiday which will prevent you hiring a car or putting petrol in it. If you intend using public transport, check that it runs on Sundays and other feast days.

When you do get to the stage of going to specific places and having to arrange meetings it all gets more complicated and you have to start organizing many months ahead. We make two or three trips a year to France, each of two or three weeks, and typically spend time in two towns each week, most of this with the assistance of the local tourist office. We take our own car, which simplifies a lot of it, and I work out a rough circular route, then write to my contact in each tourist office and say, 'We would like to come. We will be coming from this direction and going on in that direction, and expect to be in your area in this week. Will that suit you?' They write back and say, 'Yes, fine, come here from the 7th to the 9th' or 'That's awkward; I will be away then and cannot show you round. Could you perhaps make it the following week?' or 'It would be better the week before when we have a widget festival which you ought to see.' After a few more letters and a route which has often become less circular and involves some back-tracking,

the whole thing comes together and I can book our Channel crossing. If you make intensive trips like this, be sure they include weekends somewhere quiet, where you can rest and pull your notes together.

Unless there is some high-season festival which you particularly want to see, it is best to go outside the main tourist season. Not only will it cost less, but people will have more time to talk to you and the various attractions will not be so crowded. You will also, if you are travelling independently, find it much easier to find accommodation at short notice.

Even if you are not on a tight budget, it is a good idea to stay at B&Bs, especially the ones which provide a meal with the family and other guests. This is a marvellous opportunity to talk to all sorts of people who often give you wonderful tips on where to go and what to see. Youth hostels (which are not exclusively for the young) are another good place to meet interesting people. Some countries have 'meet the people' schemes, where you get an introduction to local residents of your own age and type, who will give you tea, coffee or even a meal. Ask the tourist office about these schemes.

If your programme involves any potentially dangerous activities (such as skiing or hill-walking) it is wise to arrange to do these after you have kept any other appointments. That way, even if you do sprain an ankle (or worse), you will still have something to write about (in addition to your piece on how the emergency services work!).

If you intend making several trips each year, it is cheaper to get an annual travel insurance policy than short-term ones each time you go. Do be aware, though, that you will find the premiums higher as a travel writer than the average holidaymaker or retired person; and even higher if you describe yourself as that *bête noire* of insurance companies, a journalist.

145

Press Trips and Other Free Visits

The public perception of travel writers is that we spend our time enjoying free holidays in exotic places, in return for which we have to do no more than toss off an article or two. If only it were as easy as that!

Press and other paid-for trips are just as hard work as the ones you pay for yourself, and unless you are a staff writer for a newspaper or one of the big glossy magazines who gets a press trip handed to you by the editor, they are also quite hard to arrange. Moreover, if you do not fulfil your part of the bargain by getting something published, you will soon find the word has gone round and you have been dropped from the list of invitees. It is not as easy as it used to be to obtain these trips and other 'facilities' (use this word when asking for free or discounted trips and other privileges); since the newspaper and magazine world has veered from employing travel writers to using freelances, there have been far too many wannabe travel writers who have taken advantage of the system, and the travel industry has become more careful about whom it accepts.

Some trips or facilities are completely free, others will be offered to you at a deep discount. Some will let you take your spouse or partner (called a 'companion') but may draw the line at paying for them completely unless they are also a writer or photographer. It depends on the provider's policy and what you are getting; it costs a hotel or cruise line no more to have two people in a room than one, but it does cost more to feed two, and to provide them with seats on transport.

In any case, there are some things you should always pay for yourself, such as your bar bill (not wine with meals), the car park charge for your car in hotels, any tips you feel you should give hotel staff for personal services performed, and

any hotel charges for personal services like valeting your clothes or telephone calls.

There are three main types of 'freebies' available: organized press trips, organized tourist-office hospitality, and the trips you put together yourself by requesting facilities from various organizations.

Press trips will not cost you anything other than the personal items mentioned above, from the time when you join the group until you leave it at the end. They are always group trips and they are highly organized, often with every minute of every day filled with visits to the attractions they want you to see, many of which may not be of interest to you. This intense pace can be exhausting, but you need to keep a bright, interested expression on your face, even when you are getting fed up with the unceasing flow of facts and some of your companions are less than likeable.

Press trips have various purposes: to see a new section of motorway before it opens, to visit a new theme park, to sample a new or refurbished hotel, to learn about a new resort or a region which is trying to increase its share of the market. They may be arranged on behalf of a single organization, such as a hotel group or a tour operator; or where a whole town or region is the subject of the trip, it will have been funded by all the different providers and organized by the tourist office.

These trips are not easy to get on, as they are normally offered to newspapers and travel magazines first, and freelances will only be invited if there are spaces left over. The organizers know they are guaranteed a write-up in each paper or magazine that sends someone, something that is less certain with a freelance. Since all the obvious publications will have received an invitation, they are unlikely to pay an outsider when they can have the piece for nothing by offering a trip to a staff reporter (who will not necessarily be a travel specialist; many editors hand these trips out

amongst the general staff reporters). To get on the list for invitations you have to demonstrate, by listing credits and offering to send copies of your published work, that you have been published several times in appropriate papers or magazines, or produce a letter of interest or assignment from an editor. If it is the latter, unless you get to hear of a coming trip and manage to interest an editor very quickly, it is more likely to be a matter of luck that your request for information meets with the response 'We have got a space on a press trip, would you like it?'

As long as you are confident that you can fulfil your part of the bargain by getting something published (and it need not involve every element of the trip, only those which you find of interest), it is worth accepting these invitations for the opportunities they will give you to network with the other guests, some of whom will be editors.

Tourist-office hospitality can be equally intensive, but in most cases you will be on your own and you will be asked what you particularly want to see. You will be provided with introductions to these places, or someone from the tourist office will accompany you. Most tourist offices are happy to give you three full days and three nights in hotels, plus dinner and lunch. They may be able to assist you with flights (on the national airline) or trains, or they may expect you to find your own way there.

The situation with tourist-office hospitality is slightly different from press trips, in that you can alter the arrangements if they are not what you expect or need. For instance, on one occasion we arrived in the evening at the prearranged hotel, only to find that it lacked anywhere to park the car. There was, they said (none too helpfully) a perfectly good public car park in the centre of town only ten minutes' walk away, and we could park the car there. We balked at the idea of leaving an obviously foreign car in an open car park where it would be a target for the sort of thief

who views tourists as an easy mark. So we said, 'Thanks but no thanks' and took ourselves off to another hotel which did have somewhere safe to leave the car. You may think we were being ultra-fussy, but it would have been a major disruption to a busy three weeks to have to get broken locks or windows repaired. When we presented ourselves at the tourist office in the morning, we explained what we had done and said that if it had upset their arrangements we would be happy to pay the hotel bill ourselves. 'No need,' they said, 'absolutely no problem, terribly sorry, we should have thought about parking.'

As with other assistance from tourist offices (research, general queries, etc.), hospitality may be within the remit of the director of the individual town tourist office, or at regional, or national level, either in their country or in the UK. You arrange these trips by telling the tourist office you would like to see their town or region with a view to writing about it in a particular magazine. If you can produce enough cuttings to demonstrate that you write regularly for that publication, or several from different publications but all on one destination, or a letter of interest from an editor, they will be perfectly willing to assist you at a mutually convenient time. And if you can show them a contract for a guidebook they will welcome you with open arms. Remember that you may need to approach the main tourist office in the country in which you will be published if it is not the UK.

You should also be aware that staff in different tourist offices in each country meet each other at conferences, and that their career progression could be from a small town office to a regional office to the national office in London. And do not think that they don't discuss the writers they have dealt with, especially the bad ones. We were told one horror story of a writer (not British, I am glad to say) who kept changing the arrangements and finally turned up with

a badly behaved dog which promptly chewed the tourist office director's handbag, which he thought was hilarious. There was more of this sort of behaviour throughout his visit, and how she put up with him for three days I do not know; I would have dumped him back at the station at the end of the first day!

Putting together your own trip in the hope of getting free or discounted facilities takes a lot longer, even with those countries which do not have a national tendency to slowness. You have to do a juggling act between organizations which might be prepared to help you if you can get a commission and editors who will only give you a commission if you are definitely going, which you cannot do if you have to pay your own expenses.

The best way to approach your potential benefactors is to start by phone. If you do not have a contact name, ask for the press office or the publicity office, explain that you are a travel writer and ask what their policy is on sponsoring or assisting writers. The tone of the reply, as much as the actual words, will tell you what you need to know. You will get all sorts of responses, from 'We don't at all' or 'I am afraid we have spent all our budget for this year' to 'It depends on where and when you want to go', which will usually be followed by 'Who do you write for?' They will say that they need to see a commission letter, or that while it is fine in principle, they will not be able to give you a definite answer for specific dates until closer to the time, which means 'If we have an empty room or seat we cannot sell, you can have it.'

What you hope for, of course, is a free room, seat, etc. but if that is impossible, ask if they have special press rates or industry rates. When new tours or hotels are opening or expanding, the organizers offer travel agents and the press what they call familiarization trips, to allow them to sample the experience at a nominal price. For instance, when the

Palace on Wheels (one of India's luxury trains) was relaunched in 1999, we were offered a five-day trip on it for £99 a head.

You will have to go through this routine with each component of your trip: transport, accommodation and meals. Probably the easiest are hotels and cruise ships; the most difficult are airlines, particularly the big ones. They rarely give free seats to anyone who does not have a firm commission from one of the big-name newspapers or travel magazines (and even then they expect a bit more than a mere listing of their name). You are more likely to succeed with new airlines, those opening up a new route which just happens to be where you want to go, or foreign airlines that are new to Britain (or your target country), or which have started using more of the major airports. You may still get no better than a discounted seat but be sure that it is a confirmed seat, not stand-by, especially if you have to catch a connection or have a meeting scheduled. It is essential that you have signed letters of confirmation to carry with you, as airline check-in desks are the most prone to professing total ignorance of you or your arrangements.

From all of this you will see that while free or heavily discounted trips are achievable, you are unlikely to get them before you have established yourself as a bona fide travel writer and can prove this with cuttings of published work and letters of interest or commission from editors.

There are some ethical considerations in accepting these free trips. Apart from the obvious one of not misrepresenting your or your companion's status to obtain such facilities, there is the question of whether receiving such benefits will affect how you report the trip. Some American magazines worry about this to the extent that they will not accept work that has resulted from a free trip, and American writers' organizations include clauses in their rules outlining what they consider to be appropriate standards. UK

publishers do not worry about this; it is common to see a comment at the end of travel articles stating that the writer was the guest of ABC Airline and DEF Hotel.

The main question is what to do when you have had a bad trip, and the way you deal with this will depend on what was bad about it. If the whole thing was so dreadful you cannot find anything good to say about it there is no point in writing about it because no editor will print a piece that is all bad news; the way to tackle this situation is to talk to the organizers and explain that you were disappointed and do not feel you can write about it. There is no point in being nasty about it; if it was that bad you will not be the only one to say so and they will probably be so embarrassed about it that they will sort out the problems and offer you a repeat trip later.

If it was just one aspect that was bad in what was otherwise a good experience, it is up to you whether you mention it in your article. The test is whether it was an inherent problem of the locality (the town was infested with pickpockets), one of generally sloppy management (the hotel staff were all rude) or an isolated incident that is unlikely to be repeated (the quality of the food was erratic but this led to a change of chef and will not happen again). In the first case, you can warn your readers: 'Wheretown is charming, but watch out for your possessions on market day, which attracts pickpockets as well as shoppers.' In the second case you could report that Wheretown was charming and not mention the hotel, or say 'Wheretown is charming, except for the staff of the Hotel Grotti, whose manners left something to be desired.' In the third case, since the problem is solved, there is no need to mention it. If your stay was marred by bad weather you need to find out if it was a fluke or if it is always like it at that season, then say 'Wheretown is charming, but do not go there in September, when it rains a lot.'

Finally, make sure the first thing you do when you get home is to send thank you letters to everyone who has extended their help and hospitality to you. For tourist offices particularly, correspondence which shows they are doing their job, and doing it well, helps them justify the funding they have received and expect to receive in the future.

And do not forget to send them a copy of everything you have published which mentions them, even if only in passing.

What to Take with You

When we go off on our European tours in our large car, we can take everything we might need, from a selection of dictionaries, guidebooks and field guides to the fauna, flora and lepidoptera of Europe to several bottles of Scotch for spreading goodwill. When you are travelling by air, train or bus you cannot be so liberal with weight. Some people solve the problem of bulky guidebooks by tearing out the relevant pages and leaving the rest at home; if you cannot bear the thought of such defacement, you might photocopy those pages.

You should carry any letters from tourist offices and other oganizations confirming appointments or other arrangements, especially when these involve free or discounted travel or accommodation. Sod's Law says you will arrive somewhere on a Friday evening when the person with whom you have made the arrangements has gone home for the weekend and forgotten to tell anyone else about it. If you have a letter of confirmation handy your problem is solved. You will need a list of all useful addresses and phone numbers and a spare copy of your itinerary in case you lose it, plus copies of some of your

published work to show to tourist offices and other people, particularly cuttings from magazines in which you hope to place articles about them.

Even if you do not intend to take photographs for publication, carry a camera to take snapshots of scenes and other interesting things. You can do this in an instant, when it could take several minutes to write sufficiently detailed notes to bring it to mind when you get home. You will need at least one notebook; put your name and address clearly on the inside of the cover and staple an international reply coupon to it so that it can find its way home if you lose it. A small torch is essential, not just in case the electricity fails but for making notes in poor light. If you are going to damp places or in the wet season, carry your notebooks in a sealable plastic bag.

Some writers like to take laptop or other small computers instead of notebooks. If you are the sort of writer who habitually works straight onto a keyboard, this is reasonable; if you are a 'handwrite first, type later' person there is no point in carrying something weighty and eminently stealable, which needs a power supply or spare batteries, unless you need to contact people or send work by e-mail. The best option if you do feel a computer is desirable (and you can cope with the minuscule keyboard) is a palmtop such as a Psion, which runs on ordinary AA batteries.

If you are concerned about losing your notes, carry a supply of stout envelopes and post them (and any bulky brochures) home at intervals. With a computer, you could e-mail copies of your notes to yourself at home. Some travel writers on long trips send more than their notes home by post. They arrange the trip so that they can send some clothes home, perhaps doing the cold countries first and sending bulky clothes home when they get to the hot countries. An alternative is to buy cheap warm underclothes and just abandon them when you do not need them any more.

It could cost less to do this than to pay for a box and the postage.

As far as other luggage is concerned, the less you carry the better, especially if you will be moving round a lot. There is a basic rule that says if the place you are going is not civilized enough for you to buy toothpaste and shampoo and have your clothes cleaned, it is not the sort of place where you should carry a stack of possessions. You should not, anyway, take anything you cannot afford to lose, but the important thing is to keep the weight down, so lightweight luggage is essential. Take crush-proof clothes that can be packed in soft bags and invest in bags which you can sling over your shoulders. Two small bags are better than one large one, especially if they are small enough to carry on to an aeroplane. If you have appointments you will need a business-like outfit, but as long as you are going where there are dry-cleaners, you should not need more than one. Invest in a coat with lots of pockets, or sew some 'poachers' pockets' into the lining. The object of all this is not just to save you waiting at airport carousels, but to relieve you of unnecessary weight and leave your hands free to reach for your notebook and camera.

9 Practicalities

Money Matters

If you are new to writing for money, let alone travel writing, and if you have never been involved in running your own business (which is what writing is), there are two things you should understand: that it is necessary to invest in a business before it will start earning you money, and that a failure to do so will be detected by those who matter and will damage your credibility as a professional. One classic mistake of beginner writers is that they skimp on stationery and equipment, buying cheap paper and envelopes (or reusing old envelopes), using poor printers or old portable typewriters with tired ribbons and thinking they can do without decent letterheads and business cards. All of this screams 'amateur' to any editor or industry personnel who encounter it. These are busy people and they have neither the time nor inclination to waste time on amateurs.

If you are not serious enough about being a travel writer to spend a little time and money on equipping yourself, you might as well forget the idea, for it is a very competitive genre, full of very professional people. If your only reason for writing is to subsidize your own travels, there are other ways to do it (some of which are mentioned in Chapter 10).

To ease the pain of the initial expense of setting yourself up with decent stationery and office machinery, remember that the expensive items (for instance a computer) will last four or five years before they need replacing. Divide the cost by five and ask yourself how many articles you will have to sell each year to pay for it; at the meanest rates the answer should only be two or three. The same piece of arithmetic applies to the cost of your early trips; as long as they provide enough material for several articles over a reasonable period, you will soon earn back what they cost.

The Inland Revenue understands that it takes time and investment to get new ventures up and running. As long as they are convinced that you are seriously trying to make a profit, they will accept losses for the first few years, and even let you set those losses against other tax you may have to pay. As a writer, the expenses you can set against your earnings include stationery, postage, office equipment, heat and light, phone calls and research expenses. As a travel writer, your travel costs are part of those research expenses, as are any special equipment you may need for parts of that research (for instance, riding clothes for a horse-back safari in Kenya). As a UK taxpayer you do not have to match a particular set of expenses against a particular payment for an article; research is considered to be something which increases your general knowledge of your subject as well as allowing you to write a particular article.

There has been some concern that the taxman might consider free trips to be a 'benefit in kind' and make travel writers declare the value of the trip as part of their earnings. The arguments against this are that you would not have gone at all if you had had to pay for it, and it was thus not a pleasure trip, and that if you had had to pay for it you would have been claiming that cost as expenses, so the two sides of the equation cancel out. If you spend one week working and another having a holiday, or if you take a

companion along and they are having a holiday while you are working, you will have to make proportional adjustments on the amount you claim.

Taxation is a complex matter and it is always best to let an accountant deal with it for you, and also to stand between you and the Inland Revenue in case of arguments. Just make sure you keep full details of all your expenses and every receipt, plus copies of all your query letters to editors, together with any rejection slips you may receive, so that you can prove you really are trying to sell your work.

If you are VAT registered, check with your local VAT office what the arrangements are for claiming back equivalent taxes charged abroad. The amount charged in these taxes is considerably more in some countries, so this would be a worthwhile saving.

As far as currency for your trips is concerned, all the usual options of cash, travellers' cheques and credit cards are available, but probably the easiest way to keep track of your business spending is to get two additional credit cards, which you only use for business expenditure (one Visa, one MasterCard, in case you encounter a situation where one of these is not accepted). With credit cards, in most countries, you can obtain cash from machines just as easily as you can here and this is often less trouble than going to a local bank, where you may have to produce your passport and complete numerous forms.

As far as cash is concerned, if you go to one particular country regularly it just is not worth bothering to change money back when you get home, paying double commissions in the process. One useful thing about driving through Europe is that the motorway service stations have tills which accept any currency and give change in any currency. And everywhere in the world, no matter how remote, you will find someone who will accept American

dollars, so it is worth carrying some for emergencies.

One problem that you will encounter if you sell your work abroad is the cost of converting currency. We are one of the most expensive countries in the world in that respect, with a large fixed fee per transaction as well as the exchange-rate bands, and converting small payments can cost so much proportionately that it makes the whole exercise Pyrrhic. There is no easy way round it, either, unless you are on sufficiently good terms to ask the editor if you can be paid in sterling or euros, or to be paid for several articles rather than for each one separately. Some banks in the UK will open foreign-currency accounts, but by the time they have added the usual charges for not keeping a large credit balance, you are back to where you started. If you do a lot of work for American publishers, it is possible to open an account there (and I am told the easiest way to do this is actually to go to New York, pay in the required minimum sum and wait one day to collect the documentation), and then pay all your American earnings into it, writing yourself a cheque to pay into your UK account whenever a sufficiently large amount has accumulated to make the charges less significant.

What Equipment Do You Need?

To any other sort of non-fiction writer one can say, 'While a computer is best, you can get by with a good typewriter'; to a travel writer one has to say, 'You really need a computer with Internet access.' This is because things are changing so fast in the travel industry that you will have difficulty keeping up if you cannot look at websites. It is a rare tourist office now that does not have a website and e-mail, and the Internet is absolutely the best place to organize cheap flights and other components of your trip if you do have to

pay for them. You will find travel forums excellent for industry gossip and tips, and writers' forums excellent for up-to-date information on what various publications are doing, who to approach at which tourist office or PR company and all sorts of other valuable stuff.

In addition to the not inconsiderable possibilities for selling your work to websites and service providers, which means you must both contact them and send your work by e-mail, more and more print publishers are going over to e-mail as a method of communication. I submit more than half my work this way, quite a bit of it to other countries.

As an example of the cost effectiveness and general convenience of this, I recently wrote a chapter on English gardens for an American guidebook publisher. It was a rush job, and required daily communication for almost a month as we worked out which gardens to include and how to structure the whole thing. With a five-hour time difference I could not have spoken to them before lunchtime here, but could get e-mail queries to them and the answer back in several hours easily; I e-mailed my queries in the morning and got the response by tea-time. This cost me no more than a brief local phone call to my service provider's local number, whereas a phone call or fax would have cost several pounds. And when the chapter was completed I sent it by e-mail, which took less than three minutes at local phone rates, whereas faxing it would have taken the best part of an hour at international rates. The e-mail facility on that job must have saved me over £100 (or 10 per cent of the cost of the computer).

Even if you do not become involved in the Internet or e-mail communication, many publishers like to have a disc as well as paper copy. Then there is the difference in quality of the printed work a computer word-processing program produces: no typing corrections because you make sure it is all correct before you print it, fewer spelling mistakes

because you use the spell-check facility (although you still need to give it the eyeball test because many spelling mistakes are still proper words).

In addition to all this you have the important facility of being able to keep standard letters on file and just alter the relevant parts instead of having to retype the whole thing. And what is more important, you can tailor your list of publication credits to suit the query letter you are sending, putting the articles about Mexico at the top if your query is suggesting a piece about Mexico, moving them down and replacing them with articles about Canada if that is what you are suggesting, putting the guidebook chapter at the top if you are proposing writing a guidebook. Then, when you start getting some credits from prestigious magazines, you can put those in a prominent position at the top and drop the mention of the piece you wrote for the *Saggar Makers' Gazette*.

If you really cannot afford to buy a computer yet, most libraries now have them available to hire by the hour, and there are cyber-cafés in most big towns where you can surf the Internet.

You may find a fax useful, although less so now that more people are using e-mail. However, if you have the modem in your computer that lets you send e-mail, you can get software that also allows you to send and receive faxes.

You certainly need a telephone answering machine to take messages when you are away. Whether you need a mobile phone is dependent on where you go; if it does not work in the country you are in there is no point in having it, and you will just be carrying something else that is eminently stealable. I have never found a need for one; I find tourist offices are very accommodating about phone calls and I carry a phone card for emergency use.

Good-quality letters and business cards are also essential. The letterheads do not have to come from an expensive

printer if you have a computer because you can design them, store them in a document and call them up every time you need to print a letter, which you then do on plain white paper. Buy one ream of good bond paper for letters; you can use a lighter weight (80 or 90 gsm) for printing articles. The design of your letterhead should be simple and businesslike, with no clever logos. The words 'travel writer' will be sufficient. The same applies to business cards; simple print on white or cream card is universally acceptable. Do not forget to add the international dialling code for the UK, (usually expressed as '+44') then the first zero of the number in brackets, thus: '+44 (0) 1234 56789'. As an ordinary writer in the UK you may not need business cards but as a travel writer you do. Many foreigners are much more formal than we are (there is considerable etiquette and much bowing built into the giving and receiving of cards in Japan, for instance), and they will be surprised if you do not carry cards. Take a lot, as by the time you have handed them out to every hotel manager, restaurateur, museum curator and olive-oil mill proprietor, let alone tourist-office staff, you can easily get through twenty-five or more a day.

Professional Travel Writers' Organizations

Whether or not you join one of these organizations is up to you. You will not be refused work if you are not a member: editors judge writers on their ability to string words together and to deliver what they have promised on time. Travel-industry people judge you by the number of articles or books you have had published and how good a job you have done of describing the delights of your subject matter. I carry a press card but have never had occasion to produce it; business cards and my portfolio of sample cuttings do all I need.

You may find it useful to network with other travel writers (and possibly editors) at organization events and you may find them a useful shortcut for information on PR companies which represent the industry. If you are a member, your name and address will go into the yearbook which is distributed to PR companies and the travel industry.

The two main travel writers' organizations in the UK are the British Guild of Travel Writers (BGTW) and the Outdoor Writers' Guild (OWG). In both cases you have to be an established professional to join, proving this by producing a certain number of articles published in the last year and demonstrating that the requisite proportion of your income comes from travel writing. Addresses for both are in the Appendix.

Beware of organizations on the Internet which say they can give you professional travel-writer status. Most of them are not what they purport to be and you will get no more for your money than a pseudo 'press pass', car screen stickers, a list of potential markets which you can get elsewhere for less money, and not much else. If in doubt, ask members of Internet writers' forums for their opinions of such organizations.

If you are making your living from writing, you might also consider joining the National Union of Journalists (NUJ). You do not have to be a member to write for UK newspapers or magazines, although there are some mean editors who will ask you if you are a member and try to underpay you when they find you are not. The NUJ publishes an excellent *Guide to Freelancing* each year, which lists the recommended rates of pay for all types of writing, editing and photographic work.

If you write books, you should certainly join the Society of Authors, which you can do as soon as your first book has been published. The Society has a legal department which

can advise you on book contracts and other areas of professional interest, holds seminars on various topics and publishes an excellent quarterly magazine, *The Author*.

10 Where Do I Go from Here?

What else can you do that will both assist with your travelling ambitions and bring in some money?

Other Genres

The first and most obvious possibility is to extend your writing to other genres besides travel. You may already be doing this; very few travel writers write only about travel and even the BGTW does not expect you to derive all your income from travel writing. As mentioned in Chapter 3, many of the sub-genres within travel writing (food, gardening, sports etc.) are easily entered through the travel doorway and something that you have seen on your travels, such as the new method of pruning roses I mentioned, can set your thoughts going in new directions. What you actually do in this situation is persuade editors to see you from the opposite direction: instead of being a writer who covers gardens abroad, now you are a travel writer whose experience of gardening abroad has given you expertise in gardens in the UK.

Speaking

The next step is to move from writing about travel to speaking about it. There are numerous organizations, from

Townswomen's Guild to small local travel clubs, which are in constant need of speakers. Your topic could be 'My Life as a Travel Writer' or any aspect of your trips or your speciality: 'Back-packing in the Karakorum' or 'The Renaissance Frescos of Central Italy'. Some of these groups like talks to be accompanied by a slide show; most expect you to speak for about an hour and answer questions at the end. The pay is not tremendous but it does give you the opportunity to talk to readers and to find out what they are most interested in, which helps you to detect growing trends and write convincing query letters to editors: 'At my speaking engagements, I am noticing a trend towards ...'

Becoming an Inspector or Tour Guide

Another possibility, which could be combined with guide-book research as well as generally getting you into places you might otherwise not have thought of going, is to be an inspector for accommodation guides – not the big-name ones, as they tend to have teams of professional inspectors with hotel-management qualifications, but the smaller guides which list B&Bs, small country inns and so on. There is usually an inspection season and you will be assigned an area to inspect, with an arranged programme of several establishments to visit each day. You will have an overnight stay in one of them, but just look round the others to check that standards are being maintained and everything is still as described in the guide. You will need fluency in the local language. For all of this you will be paid a set fee for each inspection and a little more for the overnight stay, plus a mileage allowance. Again, the pay is not enormous but it is all grist to the mill.

You might become a tour guide or leader. An elderly gentleman of my acquaintance alerted me to this possibility.

Retired from his job, he had always been a keen rambler and now makes four or five trips a year, leading groups of like-minded people on walks in locations as diverse as the Dolomites and the Pamirs. It is easier to get these jobs if you have some form of expertise (alpine flowers, say, or Dutch painters for tours of Holland) but not impossible if you do not. And if my friend is anything to go by, you will come back with plenty of material to write about. Ask about possible opportunities for this work from appropriate tour operators.

Mature single gentlemen are, incidentally, in great demand by cruise-ship lines as 'walkers' and hosts for the lone ladies who make up a high proportion of cruise passengers. Take your own dinner jacket.

Moderating Forums on the Internet

If you are an experienced web surfer, you will be aware that forums and chat groups have moderators who guide new members through technicalities and etiquette, deal with frequently asked questions, maintain the forum libraries and generally oversee the whole thing. If your own service provider or favourite website already has a travel forum, enquire if they have any vacancies for moderators. If they do not have a travel forum, send them a proposal to start one.

Using Your Contacts and Experience in Other Ways

If, like me, you have some expertise in, and interest in, small businesses (another of the topics I write about), you will inevitably find yourself talking to business people abroad and often find they are looking either for PR

representation in the UK or for British-based agents for their products. Even if you are not inclined to take on these jobs yourself, you can earn a nice commission by introducing them to someone who will. I also know of several people who have started what are now thriving import businesses after seeing desirable products abroad. For more information on this, contact the organization Wade World Trade (see the address in the Appendix).

You may even be asked, as I have recently, if you would care to translate a book into English. I would not consider this if it were the other way round, but since it is a cookery book and I know how to cook, and since I have a good dictionary, I am seriously thinking about it.

Self-publishing

As well as selling your travel writing to outside publishers, you can publish it yourself, either in the form of books or newsletters.

You may have an excellent idea for a book but be unable to find a publisher who is prepared to take it on. Often the reason is that they do not think it will sell enough copies in an acceptable time-scale to repay them for the effort (remember that even the lowest economic print-run for a publisher is going to be 1,000 copies and that they have to pay for warehouse space). So why not publish it yourself? Many successful small publishing houses started this way, including Survival Books, who now have over a dozen books in print.

The thing that you can do as a self-publisher, which is not feasible for major trade publishers, is concentrate on specialized marketing. You can also have as few as twenty copies printed and bound at a time, so you do not have to invest an enormous amount of money in your project.

The best types of book to self-publish are either those for a special-interest market or those which cover a small area of the country. The special-interest books, such as our *Flamenco Aficionado's Guide to Western Europe* can be sold either through mail-order advertisements in the specialist magazines which enthusiasts read, by taking a stand at competitive events which enthusiasts will attend, or by giving talks or lessons to enthusiasts or potential enthusiasts.

The 'small area' guides, for instance *A Walker's Guide to Haunted Borsetshire* can also be sold through mail-order advertisements in appropriate magazines (*Ghost-hunter's Weekly* as well as *Borsetshire Life*) and at any lectures you may give to ghost-hunters throughout the country or to the Borsetville Women's Institute. Another way of selling these books is through various shops in the area itself. Most booksellers, even the big chains, can be persuaded to stock books on local topics, as can newsagents, tea shops, gift shops, and if your topic is appropriate, even pubs.

If self-publishing seems like a good idea, before you make any financial commitments, read some of the many available books on self-publishing and talk to some of the self-publishing help groups. It may turn out to be the start of a whole new lucrative career.

Another area where self-publishing might be profitable is newsletters. If you become aware of a specialized group of travellers, who could be anything from wheelchair-bound vegetarians to fanatical cruise-takers, and you either share their problem or enthusiasm or know enough about it to produce a regular flow of writing about it, you are in a good position to start a newsletter.

Unlike subscription magazines, which need a lot of start-up money, you do not need to risk more than a few hundred pounds to start a newsletter. All you need is a word-processing or desk-top publishing package for your

computer and a friendly local copy shop. It is normal for newsletters to be printed in black only, but you should spend a few pounds on a designer to produce a logo and title-bar for you. You do not need to have each issue printed in thousands; just enough to meet your subscriber requirements.

Newsletters can be published anything from four times a year to monthly, and because they contain specialized information which subscribers cannot get elsewhere, they will be happy to pay between three and five times the cost of printing and postage. So if your production and postal cost is £1 per copy you should be getting an annual equivalent of between £3 and £5 for a twelve-, sixteen- or twenty-page newsletter. You will have to spend some money on a regular basis on advertising for subscribers, but a press release to appropriate magazines when you launch will also bring in some subscribers, as will word of mouth once you are up and running. Experienced newsletter publishers say that the point at which you start making serious money is when existing subscribers renew their subscriptions at the end of the year (because it did not cost any advertising money to get them).

You should keep subscription money in a separate bank account in case you need to make any refunds, as well as for general good accounting practice, and you may need to comply with the Data Protection Act (relating to the database list of your subscribers). However, keep in mind that lists of people with special interests are eminently sellable to list brokers.

Although newsletters do not usually carry commercial adverts (you might have a small classified advert section for subscribers), it is normal practice to include separate advertising flyers in the envelope. The least you should expect from the providers of the flyers is that they pay the postage for that issue, but once your subscription list is big enough you can expect more than that.

Other than the few hundred pounds it will cost to get started, it will only cost your writing time for as long as it takes for the subscription list to grow to a stage where you are making a decent profit. You can, of course, still sell that writing to other publishers outside your own circulation area.

Finally, because you can guarantee publication, you will be in a good position to obtain highly desirable free trips.

For more detailed information on publishing newsletters, read Graham Jones' book *How To Publish a Newsletter* (How To Books).

Appendix – Useful Addresses

British Association of Picture Libraries and Agencies (BAPLA), 18 Vine Hill, London EC1R 5DX. Tel: 020 7713 1780, website: www.bapla.org.uk

British Guild of Travel Writers (BGTW), 5 Parsonage Street, Wiston, Huntingdon, Cambs PE17 2QD, website: ourworld.compuserve.com/homepages/BGTW/

National Union of Journalists (NUJ), Acorn House, 314 Gray's Inn Road, London WC1X 8DP. Tel: 020 7278 7916, website: www.nuj.org.uk

Newsletters in Print, Gale Group, Watergate House, 13-15 York Buildings, London WC2N 6JU. Tel: 020 7930 3933

Outdoor Writers' Guild, 27 Camwood, Clayton Green, Bamber Bridge, Preston PR5 8LA, website: www.owg.org.uk

Society of Authors, 84 Drayton Gardens, London SW10 9SB. Tel: 020 7373 6642, website www.authors.org.uk/society

Travel Marketing Sources, 5337 Collee Avenue, 258 Oakland CA 94618, USA. Tel: 001 510 654 3035

Travelers' Tales Inc., PO Box 610160, Redwood City CA 94061, USDA, website: www.travelerstales.com

Ulrich's International Periodicals Directory, R.R. Bowker, New Providence NJ 07974, USA

Wade World Trade, 40 Burnhill Road, Beckenham, Kent BR3 3LA. Tel: 020 8663 3577

Index

INDEX